INTRODUCTI
CHAKRAGRAPHS

PAINT YOUR WAY THROUGH THE SUBTLE BODIES

JAMIE HOMEISTER

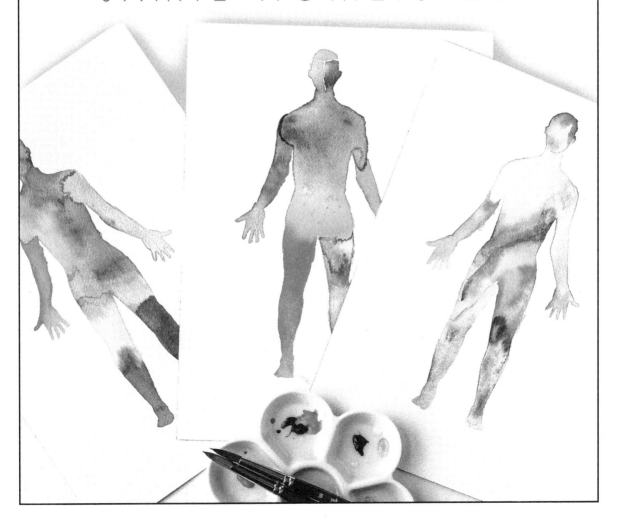

© 2021 Jamie Homeister

Chakragraph and The Chakragraph System and associated logos are registered trademarks of Jamie Homeister.

ISBN: 978-1-7350726-9-2

10 9 8 7 6 5 4 3 2 1

Published by Wyrd & Wyld Publishing
Spokane, WA

Designed by Heather Dakota
www.heatherdakota.com

© Adobe Stock photos on pages 38, 56, 59, 61, 63, 65, 70, 71, 72, 73, 108, 109, 110, 111

Photographer: MaryBeth Bryant
www.candidmb.com

Photographer: Jess Amburgey
www.jessamburgey.com

Illustrator: Megan Mraz
www.hellomeggo.com

For my husband, who is my angel upon this Earth. Thank you for your consistent support, encouragement, and love.

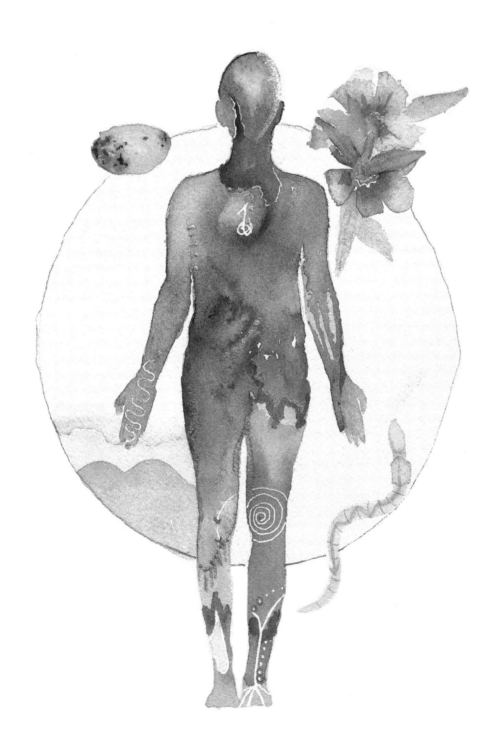

INTRODUCTION TO CHAKRAGRAPHS

PAINT YOUR WAY THROUGH THE SUBTLE BODIES

Jamie Homeister

TABLE OF CONTENTS

CHAPTER ONE

INTRODUCTION

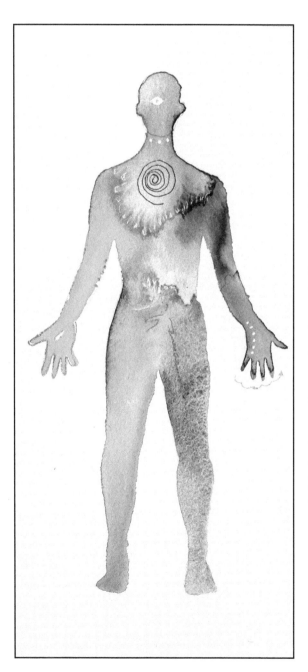

Too many of us hold false beliefs that we must be born artistic to paint or be born a **psychic** to tune into our intuition. Each of us is born to live a life abundant with connection and creativity. All of us can paint and all of us can (and do!) intuit.

You are intuitive. You can connect to **Spirit**. Yes, some of us come prewired to know, hear, or see a little easier, but that doesn't mean that everyone else can't. All you need is the desire to learn, sincerity to falter, and patience to continue.

As prized as a happy life can be, painful memories may elbow in from time-to-time. We're taught to reach outside of ourselves for relief. Shopping, social media, dieting, and alcohol become the crutches we depend on rather than use in a healthy way. I am no exception.

Unresolved trauma from my childhood—abuse, abandonment, alcoholism—turned my soft, creative heart into one filled with insecurity and shame. I was codependent, quick to anger, and obsessed with other peoples' opinions of me. Despite my insatiable hunger to live gently and "do good," my life became nothing more than a safe house protecting all my childhood anguish and pain.

The Breakdown

The early afternoon sun crept through the cracks in my blinds and spread streaks of soft, buttery light across the floor of my studio. I glanced outside and watched the heat waves radiating off the earth. The end of June was here, and the temperature neared 100°F. It wouldn't be long before the summer's insufferable humidity would begin to sneak indoors. That meant I had to work fast. If I procrastinated any longer, the paint would dry, and my feather would be ruined.

Only three hours left, I thought and glanced over my canvas again. While I had been painting for only three years, I experienced a small taste of fame. My artwork, intricate wildlife paintings on bird feathers, went viral. Collectors all over the world showed interest in my art. While I should have been ecstatic, I learned that confidence doesn't grow in stride with success. I continually undervalued, under-priced, and over-criticized my artwork.

Come on, Jamie! Focus! There was no room for mistakes. I saw each painting as another opportunity to prove that I belonged in a world that didn't even know I existed.

I scanned my studio for something recognizable, something I could anchor my mind into as the throes of panic rose into my throat. A candle burned in the corner of my studio, and I slowly melted into its flame.

Immediately, I was eleven-years-old again, seated in the backseat of my mother's grey, 1984 Ford Tempo. It was summertime in southern Alberta, and we drove through the heartland of its prairies. While my mother, captain of the day's adventures, perched herself behind the wheel, my siblings and I spread ourselves across the open seats.

The flick of a lighter caught my attention. I watched my mother pull a long drag off a cigarette and exhale. The stench of hot, fresh smoke filled the car and burned the inside of my nose. I rolled my window down in a desperate search for a cool, Canadian breeze to revive me. My focus shifted back to the prairies passing by, but I caught something dancing from the corner of my eye. I looked up to see my mother's soft, red, billowing curls dancing like flames on the ceiling. They had pulled themselves free from the bun that rested loosely at the nape of her neck. Each strand unfurled itself into a long row of color. Streaks of strawberry, brass, and copper clashed against the car's drab, gray interior. She reached down and popped open a tab on the beer can pinched tightly between her thighs. A loud, familiar *Hiss* sounded throughout the car, even over the screaming of the wind.

Together the four of us cruised the provincial back roads, spending hours wandering through it's hundreds of miles of farmlands. We had no real destination in mind. We only sought an afternoon of freedom from the pressures of being poor in a small town.

As the hours passed, my mother's shoulders slumped and her words slurred from her drink. We wove our way back home, continually crossing the solid yellow lines.

Our country cruises were one of the few ways my family knew how to bond. These outings were our way of expressing our anguish and discomfort at being the poor kids in town. Even though my brother and sister were minors, they still drank along with my mother, whose alcoholism escalated over the next two years. I met her suffering with defiance and anger.

Inevitably, our family drives became my gateway into drinking, too. I first left home at twelve years old, and permanently took my leave just shy of my fourteenth birthday. While I always found new places to go, they, too, were riddled with the same problems of poverty, alcoholism, and addiction.

My childhood years were spent living as a nomad, bouncing from house to house, social group to social group, in constant search of family, acceptance, and love. Between the ages of 12 years old and 15 years old, I cycled through more than ten different homes. Looking back, I can see how each family sought to help me within the means they had, but I was a child on a rampage, who, ironically had no real experience being a child at all.

I stole my gaze from the canvas and looked at the time. Almost two hours had passed, and I still hadn't painted anything. The brush, still poised over my feather, held nothing more than a hardened glaze. I tried to take a deep breath, but my shoulders tightened and lungs constricted. The immense weight of my grief seized itself inside my chest. I grabbed at my heart as if I could somehow keep it from shattering into a million pieces. I crashed to my knees in submission; all I could think of was to pray. I prayed to God whom I wasn't sure existed, to the Universe who had forgotten about me. I prayed for peace. I prayed until there were no more words left inside my heart. As my body collapsed, I dropped to my belly with my cheek pressed against the floor. I laid like this for the next three hours. For the first time in a long time, I thought about nothing at all.

The Awakening

The moment I begged for change something big inside me released. Almost immediately, I suffered debilitating migraines and nerve pain that would radiate from my cervical spine into my shoulders and hands. The pain made it impossible to paint. I couldn't even hold a brush.

Extreme fatigue left me struggling to find the energy to take care of my two small children.

Everyday tasks like cooking dinner or vacuuming felt impossible. I sought a diagnosis from three separate physicians, each of whom couldn't find any medical reason for my suffering, nor could they offer a solution. All I could do was lay in bed for weeks at a time and wish for a miracle.

Leaving featherwork behind meant discarding the audience, recognition, and validation I earned. The word "Artist" had become so synonymous with my identity that I felt like nothing when the title was stripped away.

My days, once rich with life became eerily quiet. I meditated and spent hours cross-legged on the floor. Almost instantly, I drifted into another head space, one where my body's new limitations were no longer the focus. I engaged in deep conversations with myself and began to hear different voices come through with the responses. "I'm open and listening. Show me what you want me to know," I said. These seemingly one-sided conversations gifted me with gentle encouragement and wisdom, and offered compassionate stories in the trials of growth. Whatever question I asked, an immediate response came through beyond anything I could have made up. Sometimes these voices carried scents with them, like tobacco, honey, or sage.

It wasn't long before these voices turned to visuals. Human forms took shape in my mind's eye. The more I focused on the sensations, the deeper the visualizations became. Then, one day, I received information in my mind about somebody in my community who had passed on. I didn't know them in life, but I learned so much through this sudden awareness. I knew the person's name, the number of children they had, their personality, the age when they passed, and their manner of death. *What did this mean?* I wondered. This happened several more times before I gathered the courage to share what I received with their families. The information was eerily accurate, and I quickly learned that I could channel entire conversations with the Spirit in real-time. No longer could I doubt that I was a spirit **medium** awakening to her gifts.

The Chakragraph Birth Story

In the spring of 2014, I was invited to participate as a medium in a local holistic fair. It was my first real form of acceptance in the psychic community.

While I was grateful for the opportunity, I lacked confidence in myself. My fear of rejection interfered with how I delivered my readings. A thirty-five-minute session took hours to complete because voice-to-voice calls or face-to-face contact paralyzed me. I could only perform readings through text messaging platforms. It was utterly exhausting, but ended up serving a greater purpose. These experiences helped me connect with someone's energy body without being swayed by body language or vocal cues. **Blind readings** built my confidence and taught me that I could successfully tune into someone else's energy, anywhere, no matter the circumstances, and obtain accurate information about the

person without needing to meet them physically. The holistic fair would challenge me because it was one of the few instances where I would give a reading in person.

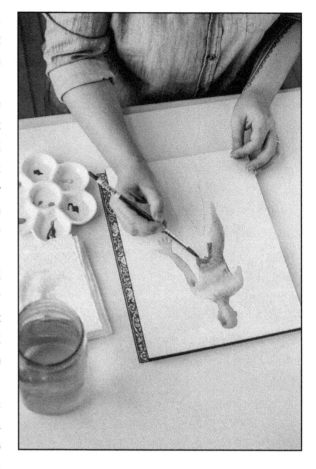

On the morning of the fair during the commute, I turned into a local supermarket parking lot feeling overwhelmed by fears. I pulled my car into one of the parking spots in the back of the lot and dried my eyes. I was due at the fair in less than forty-five minutes, and my commute took at least half that. I placed my hands over my heart and steadied my breath.

Where is this pain coming from? I asked myself. My heart flooded with memories of my awakening experience, mainly when I came out to my friends and family that I was a medium and shared my **intention** to pursue these gifts as a life path. I was met with cynical disbelief.

While our society has made great strides in accepting alternative spirituality, there remains a considerable stigma around those who claim to connect to the unseen realms. My new path in Spiritualism fractured important relationships, and the pain made me stand on my own two feet. So before I could change my mind, I took a deep breath, threw my car in reverse, and headed toward the fair.

The psychic fair was held in a large home in one of the historic districts of Louisville, Kentucky. I was scheduled to give *Reiki,* (a Japanese energy healing technique), and readings for four hours in the afternoon. The waiting room was packed with people. While the doors hadn't officially opened, the sign-up lists were filled to the brim with the names of excited patrons. The room was positively buzzing with anticipation. I was terrified.

"Please, Spirit," I prayed, "Don't let me do harm, and don't let me fail." Suddenly, I had an idea. What if I connected to the person's energy as I did with my clients in my mediumship readings? How could I quickly gain information on my client to help prepare me for their reading?

I decided to draw a little stick man on a scrap piece of paper. *Okay, this is my first guest,* I declared to my spirit team. *Show me what needs your healing energy the most.* Immediately my hand circled the

left knee. Then, I made another mark through the stomach and a third through the head. When my first guest entered the room, I gave her my doodle and explained that these were the areas Spirit showed me she has energetic blockages. She was shocked. The diagnosis was right on the money with her current symptoms: a sore left knee, constant headaches, and some severe digestive issues.

To prepare for the second reading, I repeated the same steps, created another stick man, only this time, I placed a strike through the throat and the ears. Upon meeting her, I learned that my second client was suffering from tremendous grief. She had lost her partner to a sudden accident. The incident left her without closure and the ability to speak all the things she wanted to say. Reading after reading, the positive results came in, each amazing everyone, including me.

I continued this drawing technique in all my readings, if for no other reason than to assure myself that I accurately connected to the person's energy. Without fail, they were faultless representations of my guest's physical and emotional symptoms.

Soon I replaced the stick men with body templates and the ink pen with pastels. Preparing for my first in-home event, I wanted to make an artistic gift for each guest to take home. Pastels were too messy, so instead, I reached for watercolors. They earned rave reviews, too. For me, something about the watercolor paintings just felt...*right*. The watercolor added a new dimension to the readings that I hadn't achieved through the other mediums. I quickly assigned simple interpretations to what I saw on the paper and began to use color to refine my interpretations. My color list grew quickly and my inner library of definitions were challenged and refined. Currently, I rely on 108 different color interpretations for my readings, but I began with only seven.

The Chakragraph was born out of an act of love and mercy from Spirit. It was born to help me grow my confidence as a reader and an **intuitive** person.

My little doodles helped me learn to trust myself and my impressions. These marks have never let me down, just as The Chakragraph System hasn't failed me either.

If you feel called to explore this practice, know that you already hold some form of its magic in you. There is something good waiting for you here—a teaching, healing, support, or a clearer pathway to a different reading style that feels good to you.

The Download

The Chakragraph System is a practice to help us learn more about ourselves through art and color. You learn not only about how the body is being affected by an old story but also understand the bigger question of why that story exists in the first place. Chakragraphs are an indispensable tool for a Seeker with an open heart. I consider The Chakragraph System to be a valuable tool for the conscious collective,

and I am excited to have the opportunity to share it with you. The Chakragraph System was a concept that birthed slowly over many years. To date, I have delivered more than seven hundred readings, yet I still find myself at the foot of the mountain. I am always learning, refining, and evolving my concepts and perspectives on what color means to me and exploring new ways to express how color works through each of us. I have barely scratched the surface of this system's potential. The best part is that it's not something I can do alone. You have so much to give to this process. Your practice, your insights, and your talents will further develop The Chakragraph System and help the process evolve and grow.

The learning never stops for any of us, even in our mastery. No matter where we are in life, we can continue to carve pathways at new elevations of understanding from the mountains we climb. Chakragraphs help each of us intuitively learn about ourselves. The paintings act as reflections of our subconscious, showing us the color stories that our bodies are ready to tell.

Take a deep breath and let's explore this practice through artwork and intuition.

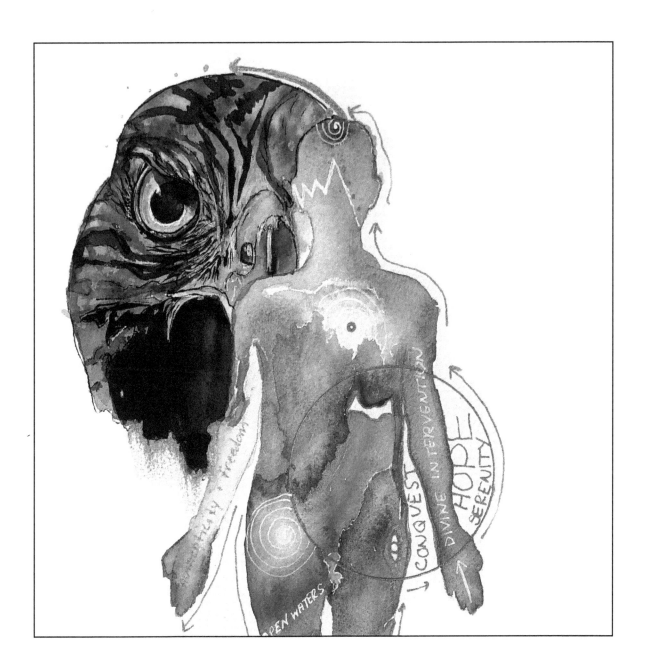

CHAPTER TWO

THE CHAKRAGRAPH SYSTEM

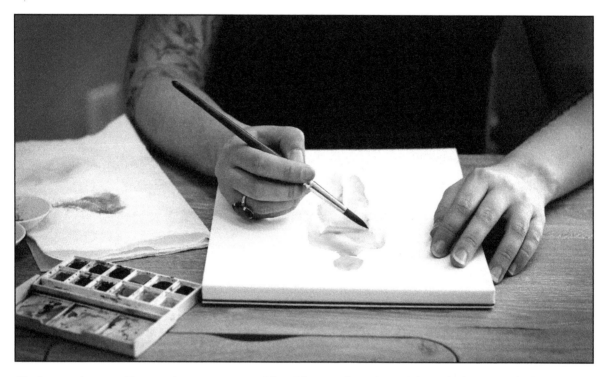

Chakragraphs provide creative ways to read intuitive art for others. The paintings speak through the subconscious, offering accurate reflections and fresh perspectives about our energetic imbalances, and help us turn challenges into opportunities through information and awareness.

Anyone can learn how to render and read a Chakragraph. Your identity, knowledge, age, disabilities, or artistic experience will not hinder your success in this program. Here's why:

- Color **divination** is an extremely friendly approach for beginners or those coming back to their artistic journey.
- A step-by-step approach makes the program accessible to anyone.
- No prior experience with intuitive work is needed. The Chakragraph System shows you how to easily access your intuition's wisdom through color.

What is Color Divination?

My color divination practice started with a curiosity about **auras**. I wondered what would happen if I tried to tune into someone's aura and track how it changed. I wanted to find a way to access information about life changes, personality changes, soul growth, ancestral knowledge, relationship issues, and even learn how trauma is stored within the **subtle body** system. How would an important life event affect a person's long-term color?

I saw color as a form of divination and worked with it like oracle cards or the Tarot. Spirit and I interpreted the meaning of every color that came up in my paintings. While each color holds a unique meaning, colors thread together to create a larger story that we use to intuit information. The results are limitless. As you grow, so will your intuitive and artistic skills, the type of information you receive, and how the work chooses to come through you.

Sacred Agreement

Each individual will receive something different from this program. No two people will have the same experience. Learning to read a Chakragraph is like learning a new language. You'll be forming a new relationship with color, and the quality of that relationship depends on the amount of attention and time you devote to it. Growth and mastery of any skill doesn't happen unless we hold ourselves accountable for developing that skill, which requires our time and energy.

A sacred agreement is a spiritual promise made from the heart. When I began this practice, I focused my intentions and energy on a higher purpose. If this is something that speaks to you, consider what intention you feel comfortable making. Here's an example of my sacred prayer. Feel free to use it or construct your own.

> *I am here to create with an open mind, without judgment.*
> *I choose to extend compassion toward myself and my learning.*
> *I knowingly create space for my body to speak and offer it a safe platform to share its wisdom with me.*
> *I welcome and invite conversation with the Holy Helpers who walk and work with me every day—my allies and trusted healers of the spirit realm who love and trust in me.*
> *I pledge to remember that each opportunity to read for myself or another is a true gift from the heart, transcending both time and worlds.*
> *I promise to extend to others the same courtesies that I make for myself here.*
> *I witness myself in compassion. I allow myself to grow in awareness. I speak up and out with kindness and sincerity.*
> *When the lessons inevitably fall on me, I remember that this is a space of acknowledgment— not expectation.*
> *I choose to be a witness to the Self, the soul, and the heart.*

Each person will be called to explore this offering for a reason. If you didn't have the potential to be successful, you wouldn't feel drawn to this practice in the first place. Trust that you will make beautiful art and accomplish wonderful things!

Mindset

Many of you may come to this practice with a background that complements this sacred work, while others may be complete beginners. Wherever you are, know that your success is based on showing up. Trust that you belong here.

Chakragraphs are a sacred offering, which means you paint in relationship with your Higher Self and Spirit Guides. This is not a space for expectations, opinions, or comparisons.

Whenever we engage in art, we court our inner muse. When we dance with our inner muse, the more creative we are in our lives and the more connected we are to the Universe. There's a ripple effect that happens, and it touches everything around us. Our world begins to brighten, and so do we.

Your mindset defines your success. Throughout the learning process, we need to check and recheck our projections while immersed in this creative process. Please remember that what you feel about your work today will not be what

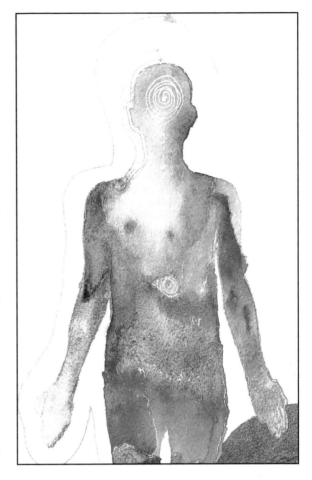

you think about it tomorrow. It's common to be overtaken by self-judgment, especially in the beginning. Self-judgment acts as a barrier and prevents you from receiving. This is one of the most valuable lessons in this program. Learn to let things be what they are rather than turning them into something you expect or want them to be.

But before we begin, let's be clear; there is no right or wrong way to do intuitive work. Throughout this book, you'll learn through my hands. I share the knowledge channeled through me and my own experiences. It may not resonate with you at times, and that's okay. I hope you feel comfortable enough to expand upon my teachings, implement your findings, and forge your unique way into this work.

Lastly, please remember that you have chosen to participate in a learning experience. A learning experience means embracing the imperfections and "mistakes" because those are our most valuable teachers. There is no pressure for results or answers. It's all about exploring the spirit of color.

Ethics and Etiquette in Your Practice

There are hundreds of seemingly insignificant moments throughout our day that affect our energetic health. When we choose integrity over comfort and ethics over ease, we can experience profound strengthening of our auras and subtle bodies.

Each of us wants our privacy respected. It is a violation of our trust and boundaries to have our energy divined, cleared, healed, or accessed in any way without our permission. Please do not access anyone's information without first obtaining their consent. This includes children. Use simple words like "Would you like me to …?" If the answer is *No*, then don't violate that boundary or access their energy at all.

Teachers

The information that comes through us is not original. Every insight, every idea, every book written, poem shared, and class created was inspired by Spirit and had been in some way born from the result of somebody else's hard work.

I honor others' creations because I know real insight doesn't come easy. Innovation doesn't come easy. Putting our ideas out into the world is not easy. However, sharing the work that inspires us is easy.

When we honor the teachings and work of others, we enhance the integrity of their offering and strengthen the integrity of our own. With that, I give my deepest thanks to the hard work of Cyndi Dale, Louise Hay, Gina Millard, Barbara Bloecher, Tori Hartman, all my helpers in Spirit, and any others I may be forgetting. We wouldn't be here today without them.

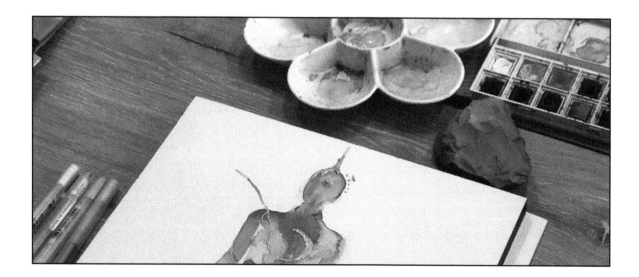

How To Honor These Teachings

This body of work is extended out into the world with a grateful heart. Developing the Chakragraph System is one of the greatest joys of my life. If you feel called to honor the Chakragraph work that you do, please share this book with others.

Please offer appropriate credit to the teachings where prompted. I offer classes for those who would like to experience these teachings in a classroom setting. Also in the works is a certified teacher program for those who feel called to lead others into this work as well. The name "Chakragraph" is a registered trademark in the United States of America.

Terminology

Over the years, throughout teaching my workshops and hosting hundreds of readings, people ask me to define terms that are common to the practice. These words are bold and explained in the Glossary in the back of this book (See Page 116).

Also, I wanted to take a moment to talk about my use of the word "Spirit" in this book in exchange of God because it defines my relationship with a higher source of power that I believe in. I encourage you to use the language that feels right to you.

The Process of Surrender

I pushed and pulled at my ideas throughout my life, scratched and clawed at anything that came. I wrestled to control every aspect of my life—my creative life, marriage, home, eating, children, self-image, healing, spirit work—you name it. My hands stirred the pot, manipulated the outcome to what I thought was best.

Everyone feels the need to control at one time or another. When we are in a struggle for control, we protect our energetic imbalances. In other words, we're nurturing our fears.

Many of us lack the training or skill set to release the stranglehold of fear. This is what makes the creative process so valuable. It's a process of surrender, not control. It's born from love, not from fear.

What does it mean to surrender? To me, the word surrender means the same as being present. When we surrender, we no longer fight against the forces of the world for our expectations or desires. We submit to the reality of what's unfolding around and within us, raising the proverbial white flag. I surrender to what is, even if "what is" feels uncomfortable in this moment.

When we are in the present moment, there is so much power to be claimed. The practice of Chakragraphs supports us by rooting back into the present by delivering real information that helps us navigate through our big feelings.

The Chakragraph System expands your inner library of personal symbolism and metaphor. This is a layered process and takes time to understand. Despite having created this system, I learn something new with every reading, so please be gentle with yourself as you're learning it, too.

The Different Types of Clairs

There are many types of *clairs* (meaning "sixth sense"). The most common types of clairs are:

- **Clairvoyance** (Clear Seeing)

- **Clairsentience** (Clear Feeling)

- **Claircognizance** (Clear Knowing)

- **Clairaudience** (Clear Hearing)

- **Clairalience** (Clear Smelling)

- **Clairgustance** (Clear Tasting)

- **Clairempathy** (Touch and Empathy)

Some people use many clairs at once and others master one or two throughout their lifetime. I have yet to meet anyone that is without one form of clair. I want you to understand that you came here with "clairs" of your own, and you'll use your unique talents to read Chakragraphs in your way. You may even discover more clairs along the way.

TIP: If you're interested in this topic, we dive a little deeper into the "clairs" in Chapter 5.

Objective and Subjective Clairs

Author, spiritual teacher, and medium Janet Nohavec teaches that for many clairs, there are two primary methods of Spirit communication—objective and subjective. Objective communication is when you see, hear, or feel Spirit on a physical level. Meaning, Spirit's communication or interaction is as clear as the interaction between two people in a face-to-face conversation. Subjective communication is when Spirit communicates through your imagination, inner senses, emotions, inner voice, visions, and dreams. Most of us, including myself, work subjectively. That means many of our talents come through our imagination and inner body senses.

We live in a consensus reality. The consensus reality is everything we can see, touch, and feel. It doesn't matter that we all see or sense things differently. clairvoyant and Shamanic Teacher, Barbara Bloecher shares that psychic and intuitive work requires us to take the next step and expand our definitions beyond what is "agreed" upon. Breaking stride with the crowd creates challenges and also expands what we know to be real. When we grow what we know to be real, we expand our consciousness and evolve." Don't worry. You've been doing this your whole life. The only difference now is that you will recognize when it's happening.

How Do You Know When Your Clairs are Working?

No two people use their clairs in the same way. That said, there is a baseline for each of the clairs that helps beginners understand their talents. Here is a brief introduction to each clair, based on my own experiences and listening to hundreds of others. These gifts appear most when the mind is focused on repetitive tasks such as doing the dishes, driving, walking, or running. They also occur when the mind is quiet, as in meditation. Mindfulness is the key to recognizing when we are receiving an impression outside of ourselves. When I realize that I'm receiving an **intuitive hit**, I simply express my gratitude and ask for more. "Thank you, Spirit. More please." This helps me acknowledge that the impression is a gift and keeps me open to receiving more in the future.

Clairvoyance is the gift of clear seeing. Objective clairvoyance is when you see an apparition or spiritual manifestation with your physical eyes. Janet Nohavec shares that true objective clairvoyance is quite rare.

Subjective clairvoyance is when a strong visual image appears in the imagination or the mind's eye. For me, this looks like a daydream. Suddenly, I get a strong impression or picture in my mind that comes out of nowhere.

Clairsentience is the gift of clear feeling. Objective clairsentience is when you physically feel in your body what the other Being feels or felt. This can relate to the past, present, or future and be in relationship with the emotions, memories, or physical symptoms. Medical mediums are considered to have a strong gift of objective clairsentience. Highly empathic folks are also said to have a strong gift of clairsentience.

Subjective clairsentience appears in the body. All of a sudden, you feel an unexpected wave of emotion wash over you despite your current state of mind. For example, you're walking through the grocery store and thinking about dinner. You pass somebody in the aisle, and a strong wave of sadness washes over you. You have stepped through the other parties' aura and received a psychic impression. You feel what they were feeling.

Claircognizance is the gift of clear knowing. claircognizance appears in the mind. It's when you know something is going to happen before it does. These events are also called "premonitions." Perhaps you think about a song, and when you turn on your radio, that song is playing. Or you're thinking about a friend, and that same friend calls you on the phone minutes later.

Clairaudience is the gift of clear hearing. Objective clairaudience occurs when we hear with our physical ears sounds like our names, music, or voices.

Subjective clairaudience occurs in the mind. It appears as a voice inside your head, often sounding like your own. You can have a constructive, compassionate conversation with this voice to problem solve, generate ideas, find solutions, and receive otherwise helpful information.

Clairalience is the gift of clear smelling. Objective clairalience happens when you physically smell a strong scent, like your deceased mother's favorite perfume or father's favorite cigars, when there are no apparent sources of the smell.

Subjective clairalience happens when we get a sense of smell coming through with a memory, such as remembering what honeysuckle smells like in winter, or thinking about a beloved grandmother and smelling her famous apple pie.

Clairgustance is the gift of clear taste. Like clairalience, this gift appears objectively and subjectively. We begin to taste the real thing (objective) or get a sense of taste (subjective) without actually ingesting the source.

Clairempathy is the gift of clear touch and clear empathy. clairempathy is the ability to feel what other people are feeling. clairempathy can also be used to feel the energy from objects, people, places, and animals. Objective clairempathy is when we translate information through our bodies. By feeling another's energy, we can get health information about the person or feel their emotions as if they were our own.

Subjective clairempathy is when we experience a sense of someone's emotions, illness, or dis-ease. We don't manifest their feelings, pain, or discomfort in our bodies, but rather a sense of what they're experiencing through our compassion.

The Reader's Responsibility

A large portion of any psychic reader's training is learning when to speak and what to say. In a successful reading, we present spirit-driven information in a way that empowers positive life choices.

Chakragraphs are tools that help us recenter in the present moment and realign to *what is*. They create a safe space for us to communicate with ourselves and others, while the artwork supports a soft delivery in a way that isn't easily found in other readings.

When reading for others, it's essential to treat the person and process with respect. As with any one-on-one work, we must respect confidentiality no matter how proud you are of the experience.

If something shows up in the chart, some aspect is ready to be witnessed by the person you're reading for. However, choose to be compassionate in your delivery and kind in your words.

Your "**line of light**" is the code of ethics you ascribe to. Recognize where your "line of light" is. Know its strengths and limitations. When we work in relationship with Spirit, we agree to be responsible for our thoughts, intentions, and actions.

For example, my "line of light" does not allow me to lie, cheat, or be dishonest with a client in any way. If I were to learn any information outside of my intuitive process, I would begin our session with a summary statement sharing what I know. In this way, we both feel confident that the information delivered throughout the reading is authentic.

Those who read for others are responsible for more than just delivering results. They are responsible for the language they use, how they make the other person feel, the messages they give, and ultimately, the consequences for any advice they offer. Deliver your messages with the same respect that you would want to receive them.

Rituals and Ceremonies

Create your own rituals or ceremonies to connect with their Spirit Helpers. My teacher, Barbara Bloecher, shares: "To create a ceremony is to create a conscious connection to Spirit from the heart. It's a free-flowing act and lends us grace to make mistakes. To perform a ceremony is about connecting honestly from the Self without necessarily expecting a result. A ceremony can be a ritual if it's continued in the same way every time."

An excellent example of creating a ceremony can be a free-form dance. Ceremony is a celebration in hushed silence. It is a powerful feeling of gratitude. Ceremonies are dedications of appreciation to our Holy Helpers in which we say with our bodies, hearts, and words, *Thank you. I invite you to this space. Please listen to what I have to say.*

Rituals are repetitive acts not conducted in the same way every time. Brushing your teeth is an example of a ritual. A catholic mass is a good example of a spiritual ritual. A ritual is spiritually-based, but may change the steps. Ceremony deviates very little from one to another. Both should be conducted with honor and reverence.

A note about cultural appropriation: To practice a ritual or ceremony not of your heritage or at an appropriate invitation is cultural appropriation. It's both unethical and out of energetic alignment to practice in this way. Sometimes it can feel very natural to fold in practices that align with our spirits. Please remain mindful of what's being grown through you, what is inspired by others, and what is taken.

What is Sacred Space?

Sacred space is any place, area, or person dedicated to a Holy purpose. It extends an invitation to the Divine, asking what we consider most sacred to join us in conversation. Sacred Space is an energetically clean and clear area for prayers to be sent, **channeling** to take place, and healing energy to be sent and received. Sacred space is a container that holds us and everything in our immediate environment in an impenetrable bubble of light. Only love can enter, and only love can leave.

Anyone can create sacred space because we are sacred space. Barbara Bloecher has gifted her students with one of my favorite mantras: "Where I walk is sacred ground. Where I am is sacred space." This moves me because it reminds me that I am sacred space, and everything I touch is sacred, too.

How to Create Sacred Space

Tidy up your physical space. A mess brings down the vibration of a room. Pick up clutter, vacuum, or sweep a dirty floor and mop, if needed. Clear any dishes or food scraps. Properly dispose of any garbage. If you have an altar in this space, regularly tend to it. Remove anything that has died or hasn't intentionally been placed there. If you work with them, add fresh water, herbs, or flowers. If you're outside, clear the area of garbage. Try constructing a mandala made from natural materials, such as leaves, pine cones, flower petals, or stones. Please do not pick anything living, if at all possible. If you do, ask permission from the plant first. If you feel a firm *No*, honor that and move on. For anything you receive or take, always give thanks. Give back to nature a strand of your hair, a little water from your water bottle, or even your breath as an offering.

Tidy up yourself.
Here are a few things to help clear your aura:
- Smudge with your favorite incense or herbs. *Note: White Sage is a common smudging herb. However, it is appropriated from Native North American cultures and is being decimated in the wild and grown with pesticides on farms. Only choose herbs you grow yourself or that come from a reputable source.*
- Spray yourself with saltwater or clearing or cleansing spray.
- Offer yourself Reiki or give yourself energy work.
- Meditate or listen to a guided meditation.
- Dance, practice yoga, or partake in a walking meditation.
- Sing! (Singing your name is very special.)

- Drum or play music.
- Take a ritual bath or shower.

Open sacred space. When we open sacred space, we imprint feelings of safety, harmony, prayer, and well-being into our immediate area. Indigenous practices may choose to open a medicine wheel. Christians or Catholics may take comfort in reciting the Lord's prayer. Witches or warlocks may cast a circle. Shamanic practitioners may call in the power of the directions. Other spiritual Seekers may open sacred space by acknowledging that there is something special out there and mindfully calling-in the good stuff. When we partake in a ceremony or ritual to open sacred space, there are no right or wrong answers. The only rule is to follow the advice that your heart speaks and do it with love.

CHAPTER THREE

MATERIALS

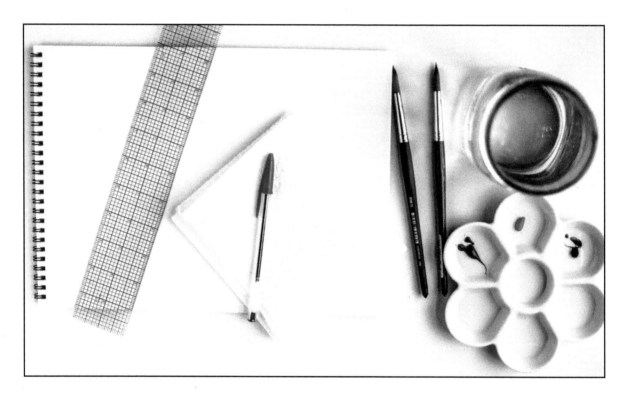

When you're using the right materials, it's so easy to fall in love with watercolor. Lower-grade paints and brushes inhibit your results and delay your learning. Upgrading to high-quality materials isn't much more expensive.

You can find all the materials listed in this book through major chain retailers. However, please consider shopping local and supporting your area's small businesses—even the smallest investments matter.

If you already have paints, paper, and brushes that you love to work with, there is no need to purchase anything new. It's better to paint with what you have rather than risk not painting at all.

Watercolor Paper

An essential component to creating successful watercolor paintings begins with your paper. Paper is the foundation of your Chakragraph work. Watercolor paper is available in three options based on its finishing process: hot-press, cold-press, and rough.

Hot-press watercolor paper is fine-toothed and best used for flat washes with minimal color or ink.

Cold-press watercolor paper has more surface texture or "**tooth**" than hot-pressed paper. The semi-rough finish makes it the standard of all watercolor paper and provides enough stability for detail work.

Rough watercolor paper is similar to handmade paper. It has an uneven, rough surface and often has a deckled edge. This paper is perfect for the wet-in-wet technique and terrific for landscapes.

Watercolor paper also comes in three different weights. The greater the paper's weight, the more water it can absorb, and the more abrasion or "scrubbing" it can withstand. The available weights are as follows: 90 lb, 140 lb, or 300 lb.

To create a Chakragraph, choose a watercolor paper that is at least 140 lb., cold-pressed. It's absorbent enough to withstand the painting techniques used in this book without being expensive. This paper has enough tooth for exciting displays of color, too.

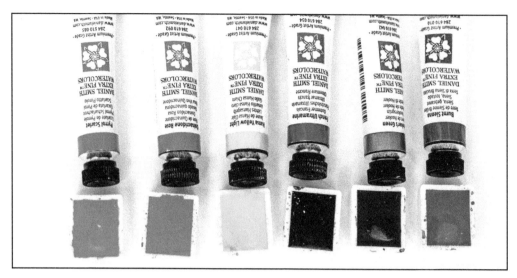

Pigments

Watercolor paint consists of three primary components: a **pigment**, binder, and solvent. The color of the paint comes from the pigment. Binders act like the glue that holds the pigment together and helps the pigment stick to the paper. Solvents dissolve the binder so the pigment becomes spreadable. (In watercolor, the solvent is water.)

There is a dizzying array of watercolor paints in today's market, from liquid to pan colors and tubed to pencils. There are hundreds of thousands of paint manufacturers all across the globe. It can be challenging to know where to begin your color journey.

One of my favorite brands of paint is Daniel Smith's Extra-Fine Watercolors. It's affordable, easy-to-access, and the quality is consistently beautiful. The colors from the Chakragraph palette are:

- Quinacridone Red
- Pyrrol Scarlet
- Hansa Yellow Light
- Burnt Sienna
- Hooker's Green
- French Ultramarine Blue

Otherwise, choose any palette that contains pink, red, yellow, brown, green, and blue.

Note: You can also purchase three colors, red, yellow, and blue and mix your own colors to create your version of the palette used in this book.

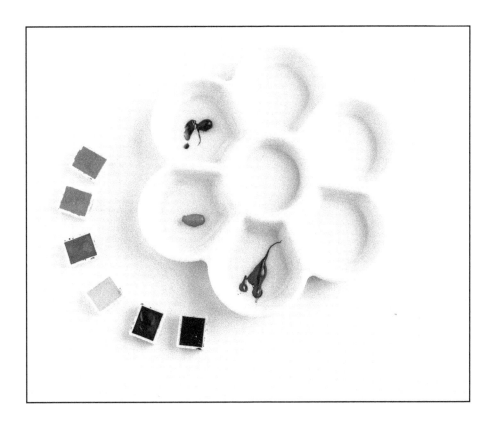

Tube, Pan & Liquid

Tubed watercolor comes pre-mixed with water components in small, aluminum tubes. The pigments are concentrated, which can make it an economical choice. A dab of paint on the tip of a brush creates an explosion of color on wet paper, but that also makes it easy to waste. With tubed color, squeeze out the amount you'll need a day ahead into empty pans or directly onto a palette and let it dry for 24-48 hours. Then, all you have to do is re-wet the paint with water to activate the color again to begin painting.

Pan watercolors are dried cakes of paint. Pan pigments come in two sizes, half pan and full pan. They are less messy to work with, thus less wasteful than tubed colors. I prefer pan colors, but choose based on your personal preference.

Liquid watercolor is an extremely concentrated watercolor that lacks a binder. They're vibrant, almost unnatural-looking, but they can be diluted with water, making them the most economical bulk watercolor paint choice. Liquid watercolor is often a non-toxic alternative to food coloring used in the classroom, children's art, and sensory crafts and projects.

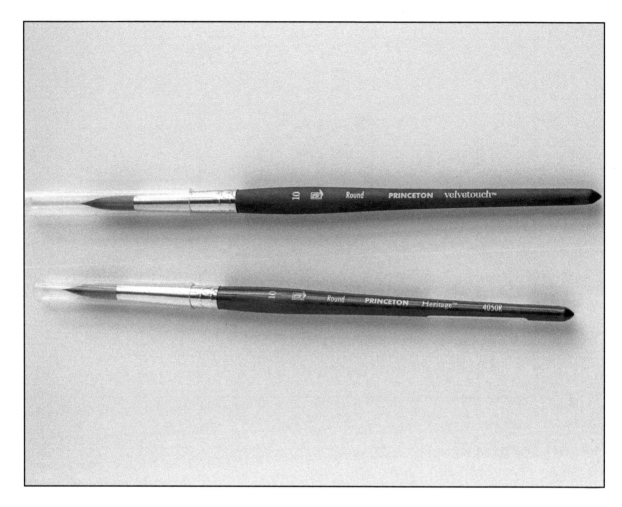

Brushes

A great brush doesn't have to be expensive. An excellent brush can be less than twelve US dollars and will withstand at least six months of heavy use when washed, dried, and stored correctly.

Choose a round watercolor brush for Chakragraph painting. A round brush has a **"belly"** in the middle that holds water and a sharp tip at the end for details.

I recommend a #10 round brush for control. I prefer synthetic fibers, which mimic animal hair. You can still purchase real animal hair brushes, but they're costly and raise ethical questions for many.

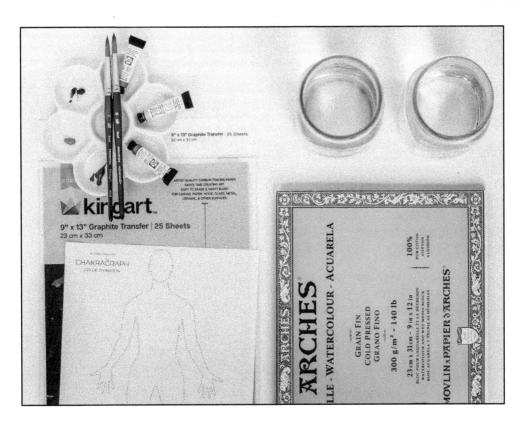

Recommended Materials

Now that you've learned about the different types of materials, here's a list of what I recommend for Chakragraph painting. For purchasing ease, I've offered a few brand recommendations based on the materials I use and a cost estimate.

#10 Round watercolor brush
Good: $4–$7 US Princeton Heritage Series, 4050
Best: $7–$12 US Princeton Velvetouch Series, 3950

9 x 12 Cold-pressed watercolor block, 140 lb / 300gsm
Good: $18–$35 US Legion Stonehenge Aqua Watercolor Block
Best: $28–$38 US Arches Watercolor Block

8 x 10 Cold-pressed watercolor pad, 140 lb / 300gsm (Practice watercolor paper)
Good: $6–$12 US Strathmore 400 Series Watercolor Paper

Paint Colors: pink, red, yellow, brown, green, and blue
Good: $12–$18 US Winsor & Newton Cotman Series: Alizarin Crimson, Cadmium Red, Burnt Sienna, Cadmium Yellow Light, Sap Green, Ultramarine Blue
Best: $18–$36 US Daniel Smith Extra-Fine Watercolors: Quinacridone Red, Pyrrol Scarlet, Burnt Sienna, Hansa Yellow Light, Hookers Green, French Ultramarine Blue

Mixing palette (A porcelain dinner plate works well)

Paper towel or lint-free towel

Two water cups or jars, one for rinsing, one for clean water

Transfer paper, also called graphite paper (not to be confused with carbon paper)

A high-quality eraser to remove any stray marks, such as Tombow Mono Eraser or Prismacolor kneaded eraser

Master's Brush Cleaner

A pencil or waterproof ink pen

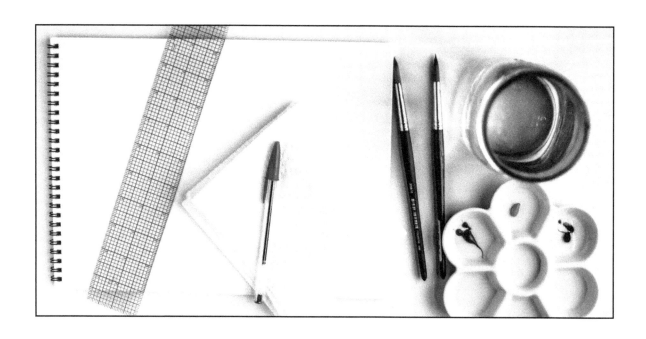

Caring for Your Materials

Knowing how to take care of your new materials extends their life. Consider these care points when working with your materials.

Paper: Store in a cool, dry place away from direct sunlight to avoid staining or warping. Lay your paper flat for storage.

Brushes: Wash with a gentle artist brush soap, such as Masters Brush Cleaner. Rinse your brush thoroughly by swirling the bristles on your palm under warm running water until the water runs clear. Lay flat on a paper towel to dry completely. Once your brushes are fully dry, store them upright (bristles facing upward) in a jar or container.

Keep your brushes clean and dry between painting sessions.

Do not try to separate the bristles using your fingers. Doing so can damage the brush's **ferrule** and the belly, which holds all the water. Avoid banging your brush to shake off excess water.

Do not let the paint dry in your brush or let your brushes sit tip down in your water for an extended time. Doing so can bend the bristles and damage the belly.

Use your watercolor brushes only for watercolor painting. While some brushes are marketed for both acrylic and watercolor, the paints react differently and affect the brush's longevity. It's best to have a set of acrylic brushes for acrylic paint and watercolor brushes for watercolor paint.

Paint: Prevent unnecessary paint loss or damage to your **palette** by avoiding over-wetting your paint. The more you work with water, the better you'll understand how much water is needed.

Mixing Tray: You don't have to worry about cleaning your **mixing tray** unless the colors have turned **muddy** and lose their transparency. By re-wetting your paint, you'll be able to reuse all the beautiful color mixes you've created.

CHAPTER FOUR

WORKING WITH WATERCOLOR

Throughout my life, I've wrestled with control in my creative work, marriage, home, eating, children, self-image, and spirit work—you name it, my hands have stirred the pot to manipulate an outcome for what I thought was best.

Being a puppetmaster of my life never ensured a smooth or positive outcome. Control only protects our energetic blockages and prevents growth. This makes the creative process and working with watercolors invaluable. It is a process of deep surrender. Surrender is about letting go of control and being present to what is. As you practice working with Chakragraphs, you'll find yourself rooting more and more into the power of the present moment.

Watercolor works through our imaginations and intuitions. If you already consider yourself intuitive or with a rich imagination, watercolors may help you use those muscles in a new way. If you don't feel like you're creative, intuitive, or imaginative, you may come to quickly find unexpected joy (and results!) in this process. Either way, let yourself be surprised!

When you set the intention to represent yourself honestly on the page, Spirit works with you and takes the pigment where it needs to go. Please trust that whatever needs to be revealed will be, and whatever you're meant to see or understand right now, you will.

I confidently assert to my clients that my Chakragraph readings last for an entire year. The information and impressions I offer span a typical timeframe of twelve calendar months. Even the most straightforward reading can take a **Sitter** weeks to unpack. It simply takes time for us to process the information we receive in any psychic or intuitive reading. It also takes time for life to catch up to the information we gather in the process. I have watched the most straightforward concepts whiz by my guest's head only because their mind is already caught up in so many different things. They're thinking about what's happening now, what you said ten minutes ago, what they hope you say, and their honey-do list for later.

I can't tell you how many times I've delivered a piece of information that couldn't be placed at the moment but was correctly identified later and was spot on. So give yourself (and others) the grace of time for things to process.

In this type of offering, the best practice is to accept how our first painting unfolds. Try not to second-guess yourself. The first piece of art you create for a reading, even if you don't "like" it, is generally the perfect one to work from.

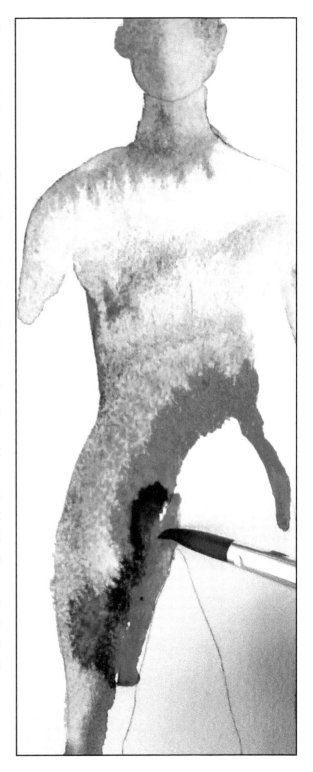

How Chakragraphs Can Help You

Watercolor makes hard things soft again. It's challenging to be ashamed of oneself when you show up on a page with a saintly halo or bathed in violet with a crescent moon for your heart.

If you practice Chakragraph painting regularly, the benefits bleed over into other areas of your life, too. Chakragraph readers report experiencing greater self-awareness, expanded creativity, a greater sense of trust in themselves and the universe, and a deeper connection with their bodies and intuitions.

One Last Note

Throughout this book, I show you how to create a Chakragraph. This is my way, but it is not the only way. I prefer to use watercolors because that's what makes me most empowered. However, I want you to be inspired by my processes and use any materials that spark your delight and interest. You get to decide how the Chakragraph comes to life on your page. By no means are you bound by how I do things. Use crayons, markers, alcohol inks, tissue paper, pencil crayons, glass, pastel—the choices are unlimited. All that matters is that you are connected to what you are creating.

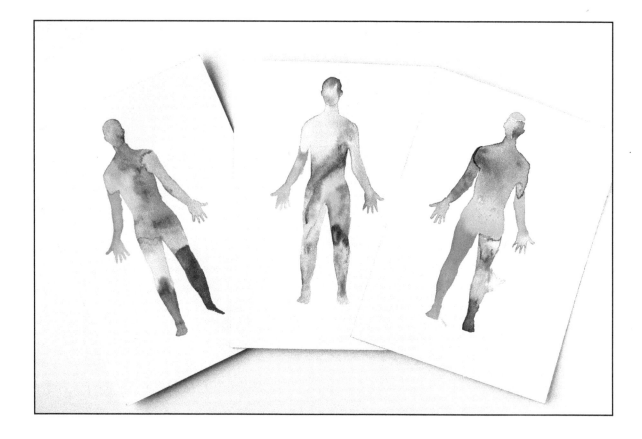

Working with Water

Learning to work with water is one of the essential facets of using watercolor successfully, making for beautiful and successful Chakragraphs. If you don't use enough water, your artwork becomes too saturated with paint and can make the Chakragraph dark and difficult to read. If your brushes are not wet enough, you won't mix or transfer your colors with ease. This may also damage your materials. Learning to work with water takes time and practice, but it will become second nature with patience.

Working with your brush

Before you begin to apply paint to your page, thoroughly soak your brush with water. Do this by swishing or swirling your brush in a cup of clean water. Then wipe the tip off the lip of the glass a few times to get rid of any excess water. Now you can load your brush with your chosen paint color.

Water puddles or "beads"

A puddle or pool of water or paint that isn't immediately absorbed into the page is called a **bead**. If you need to soak up a bead, use the corner of a paper towel, or you can use your dry brush as a sponge. If there is a substantial bead on the page, it means there is too much water.

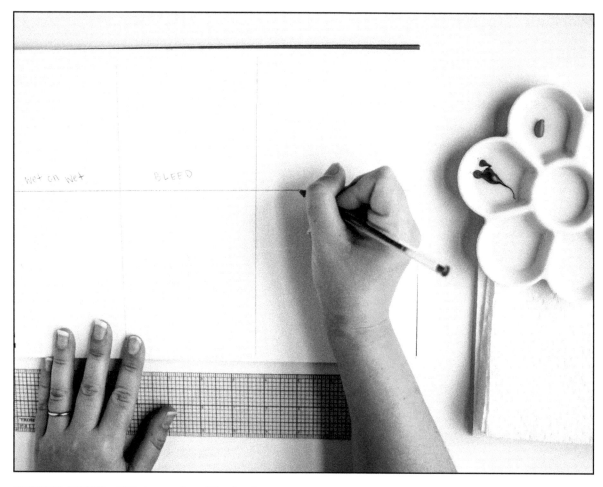

EXERCISE: Watercolor Techniques

The following techniques are simple brushstrokes I use to create my Chakragraph art. Mix and match the varying strokes in a single painting or use one method for continuity.

Materials Needed:

- Pencil or waterproof ink pen
- Practice watercolor paper
- Paint, any color except yellow (It can be too hard to see)
- Two cups of clean water, one for rinsing your brush and the other for clean water
- Paintbrush
- Paper towel or lint-free towel

Instructions:

Grid and label your paper into five sections: wet-on-wet, **bleed**, **diffuse**, wet-on-dry, and layering.

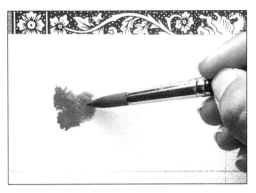
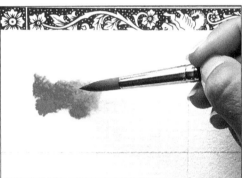
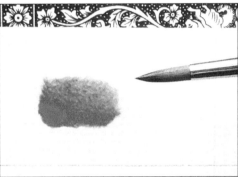

Wet-on-Wet

Wet-on-wet is a watercolor technique applying wet paint onto wet paper or paper that's already pre-moistened with water (also referred to as **priming the page**). This method creates soft edges. The wet-on-wet technique is the technique I choose to use most for my Chakragraph work, as it is the most uncontrollable and unpredictable. To do this:

1. Swirl your brush in the clean jar of water. Gently wipe the tip of your brush on the lip of your jar to get rid of any excess water.
2. Using a clean brush, paint a small square inside the grid labeled "wet-on-wet." Use only clean water, no color. The paper shouldn't have any puddles left on it when you're done. Instead, it will appear to have a nice shine when you tilt your page and look at the paper from an angle.
3. Next, load your paint onto your brush and paint over the already wet square. The colors will shift and bloom naturally as the paint dries.
4. Rinse your brush in the dirty water jar and move onto the next exercise.

Bleed

A *bleed* happens when a color naturally moves with the flow of water. We can force a bleed effect in our work by helping assist two or more colors in fusing. With a few simple brush strokes, we can easily recreate this effect for beautiful watercolor paintings.

1. Using a pencil or a waterproof pen, draw a smaller square inside the grid labeled "bleed."
2. Swirl your brush in the clean jar of water. Gently wipe the tip of your brush on the lip of your jar to get rid of any excess water.
3. Load your wet brush with paint. Using the guide you drew, split the square in half by painting a single triangle. Blot any puddles leftover by using your dried brush as a sponge.
4. Swirl your brush in the dirty water jar to clean it. Wipe its tip on the lip of the jar to remove any excess water.
5. Load your brush with a contrasting color. Paint a second triangle mirroring the first.
6. Using your brush, gently guide your colors to touch in the middle. The two colors will slowly shift together and bloom naturally as they dry.
7. Rinse your brush and move onto the next exercise.

TIP: This exercise can also be completed using the "wet-on-wet" method. First, lay down your shapes with water onto the paper. Then, load your brushes with wet paint and paint over water shapes already on the page. Try both and see which you prefer!

Wet-on-Dry

Wet-on-dry is a technique where you apply wet paint to dry paper. This painting method creates hard edges.

1. Using a pencil or a waterproof pen, draw a rectangle in the middle of your grid.
2. Swirl your brush in the clean jar of water. Gently wipe the tip of your brush on the lip of your jar to get rid of any excess water.
3. Load your wet brush with paint. Starting at the top of the rectangle, sweep side-to-side with your brush as you begin working your way down the rectangle. You should have an accumulation of water at the end of your brushstroke. This accumulation is called a "bead."
4. Using your brush, gently pull the bead down the shape until you have filled the entire rectangle. Ideally, there is an even distribution of water and paint. If you still have a bead at the end of your rectangle, dry your brush on a paper towel, and use it like a sponge to soak up the extra water in the shape. Or, you can carefully use the tip of a paper towel to absorb the water bead.
5. Rinse your brush and move to the next exercise.

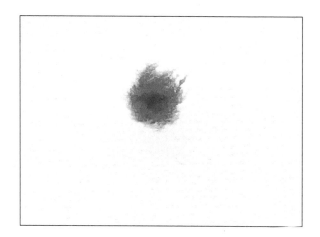

Diffuse

The diffuse technique is sometimes referred to as "drops" because you drop wet paint into a wet water shape.

1. Swirl your brush in the clean jar of water. Gently wipe the tip of your brush on the lip of your jar to get rid of any excess water.
2. Using only clean water, paint a smaller square in the middle of the diffuse grid.
3. Loading paint on a wet brush, allow one or two drops of paint to fall in the middle of your water shape—and that's it! The color will feather on its own as it dries.
4. Rinse your brush and move onto the next exercise.

Layering

Layering is a technique that highlights the beautiful, transparent quality of watercolor. It is a feature that is unique to this medium.

1. Swirl your brush in the clean jar of water. Gently wipe the tip of your brush on the lip of your jar to get rid of any excess water.
2. Load a single paint color onto your brush. Paint a single, vertical line down the length of the grid and let it dry completely. (This should take about 5-10 minutes depending on how much water you use.) Rinse your brush.
3. Once your first line is completely dry and warm to the touch, swirl your brush in the clean water jar. Gently wipe its tip on the lip of the jar to remove any excess water.
4. Load your brush with a second color and paint a horizontal mark across your original line to form a cross. You should still see the original paint color through the second.
5. Rinse your brush and let dry.
6. Store your brush with its bristles facing upright.

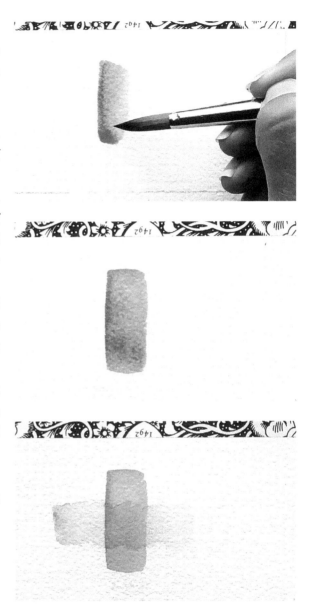

That's it! You've successfully learned five different brush techniques to paint your Chakragraphs. Which do you feel most confident working with? Which would you like to try again? Practice these brushstrokes as many times as you'd like. The more you play with them, the more comfortable you'll be creating your Chakragraph paintings.

C H A P T E R F I V E

THE CHAKRAGRAPH TEMPLATE

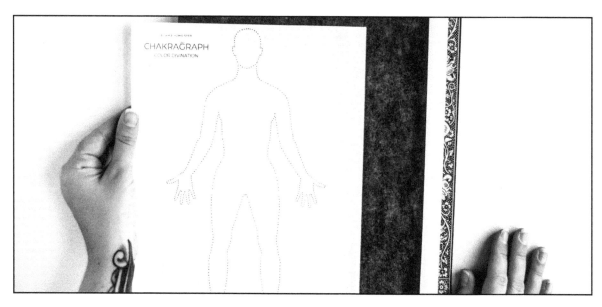

The idea to use the body template came a year before I started using watercolor for the Chakragraphs. I participated in a small mediumship group that practiced different ways to refine our psychic skill sets. One of these practices involved creating auragraphs.

Auragraphs are a creative way to give intuitive and psychic readings using art and color. In this practice, we printed a body outline from the Internet and used crayons to color the aura outside the body. We accompanied the drawing with a small reading.

To be honest, I wasn't very good at it. I didn't understand how to connect to the practice and struggled to piece together information. Nevertheless, the experience of working with all those beautiful colors inspired me. I enjoyed working with the body template, so I continued to use that element. But instead of coloring the layers outside the body, I turned the colors inward. My Chakragraph journey began by creating my own templates using pastel pencils on the print outs. The term Chakragraph came to me like a whisper in my ear one morning and the rest, as they say, is history.

The body template provides an anchor to the reading that allows us to work with something easily identifiable. I've included three templates in this book to use in your personal practice: masculine, feminine, and gender neutral. Download a fresh copy of each through my website at jamiehomeister. com/free-templates.

Finding Freedom in the Process

Even though Chakragraphs rely on a template, there is still a lot of room for creative freedom. Don't feel limited by the lines. Regardless of what template you choose, you are the creator. You will be moved to mark, paint, color, sketch, and smudge your way through each chart. The trick is to let what comes be what it is. Meaning, don't manipulate the artwork after it comes through, and that begins with the template. Resist the urge to go back and tweak your work. And definitely don't throw the transfer away thinking it is wrong or not good!

How to Transfer the Template

The template transfer is where your reading begins. You can find all the supplies listed at your local art supply store or online at any major US chain retailer. See Page 30 for the complete list.

Materials Needed:
- Graphite paper, also known as transfer paper. *Note: This is not the same as carbon paper*
- Watercolor paper
- Pencil or waterproof pen
- A printed copy of a template that resonates with you. See Page 113.

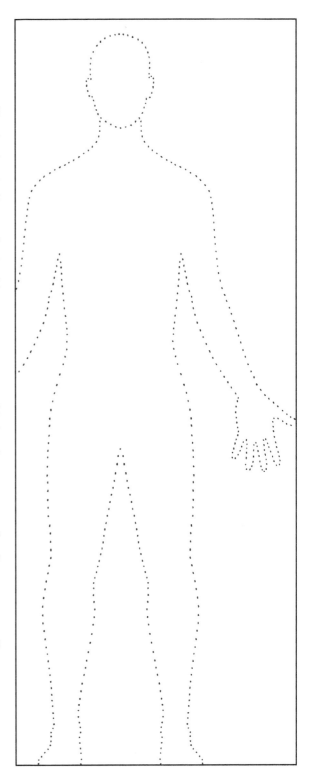

1. To transfer your template onto the watercolor paper, lay your graphite paper on top of the watercolor paper with the graphite side (dark side) touching the paper.
2. Next, place your template on top of the graphite paper's backside (light side). The order should be the watercolor paper on the bottom, graphite paper in the middle, printed template at the top.
3. Begin tracing the outline of the template with a pencil or pen.
4. Once you've traced the template outline, lift the template and graphite paper to reveal your transferred image underneath.
5. When you transfer your template and find the head missing, there's a reason for that. Perhaps you've been feeling absent lately or not present in your life. Are you on medicine that makes your mind feel fuzzy or lightheaded? Is this a message that the decisions you've made are not properly thought through?

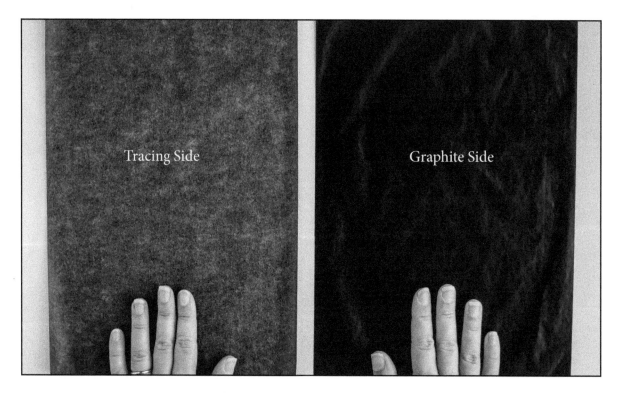

Tracing Side Graphite Side

Each graphite sheet has two sides, one side with pressed graphite, the other without. It's easy to tell which side needs to be face-down by the shade of paper—the dark side lays face-down, the light side is face-up.

Graphite paper works by indention. When you mark or press on the light side of the sheet with the graphite side face-down, the graphite transfers the image onto your paper.

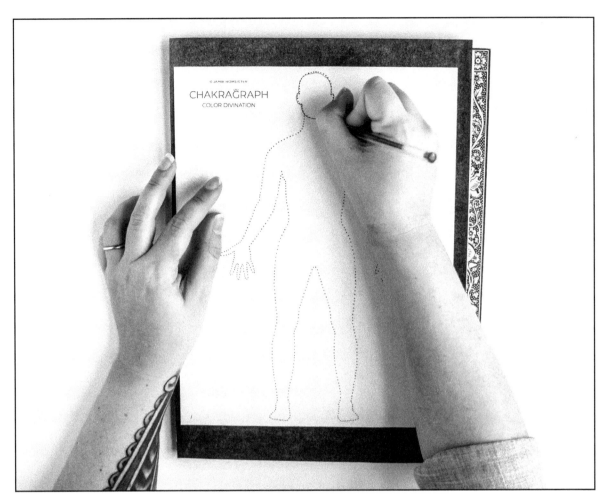

6. However the template is transferred, leave it. The template transfer will be right every time. Again, let what comes be what is. Look on Page 53 for the meaning of this missing part.

Note: Try not to move your watercolor paper, template, and graphite paper to prevent any slippage or shifting. Use painter's tape to secure the three pages together, but just holding it tightly will do the trick, too. Avoid using clips to prevent any additional markings.

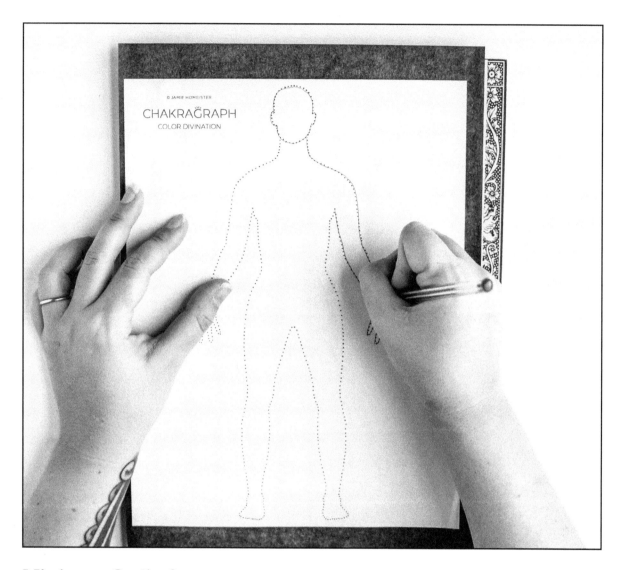

Missing an Outline?

If you traced the template outline, but no part of the image transferred, you had your graphite paper facing the wrong way. Turn the graphite paper over and repeat the process.

If you traced the template outline, but a body part didn't transfer over, you didn't do anything wrong. Make notes as to what is missing and messages that come to you. Here are some interpretations to begin exploring what the missing pieces could mean:

Missing the crown or top of the head
- Opening one's mind to spirituality
- Open-minded over the concept of God/Source/Spirit
- Discovering spirituality and/or religion
- A recent experience that brought an increase of faith and trust in oneself or the universe

Missing the ears
Right side – Having difficulty listening to other viewpoints or perspectives

Left side – Unable to hear one's voice over the voices or opinions of others

Missing the throat
Right side – Unable to speak up or articulate needs or desires to other people

Left side – Unable to acknowledge one's needs or desires to yourself

Missing the head or part of the head
- Feeling uncertain about present circumstances or the future
- Not using one's head
- Lack of clarity
- Feeling reactionary
- Impulsive
- Lack of feeling grounded
- Not feeling present
- A new state of awareness or open-mindedness

Missing the shoulders
Right side – Lack of direction in work or career, feeling disposable at work

Left side – Lack of dreams or aspirations, unsure of where to put one's efforts

Missing the arms

Right side – Inability or difficulty with completing projects or ideas

Left side – Inability or difficulty in conceptualizing projects or ideas

Missing the hands

Right – Inability to execute ideas, projects, lacking resources, or feeling a disconnection from the life they have built or are building

Left – Feeling blocked creatively or uninspired, confusion on what one wants for themselves or their life

Missing the rib cage

Right side – Lacking structure or stability in the life that you've built

Left side – Lacking structure or stability in yourself or your behaviors

Missing a hip

Right – Unable to sense one's internal compass, feeling confused about your direction

Left – Too many or too few choices, feeling stuck or trapped in your decisions

Missing a thigh

Right – Lacking connection in current relationships to others

Left – Lacking connection to familial relationships, or feeling as though you didn't have a connection with others as a teenager

Missing a lower leg

Right – Lacking connection to the future, unable to conceptualize what's next

Left – Lacking connection to early childhood, missing memories of childhood

Missing a foot

Right – Feeling unsure about the future, feeling unsteady on one's own two feet

Left – Feeling a lack of connection to ancestry and family

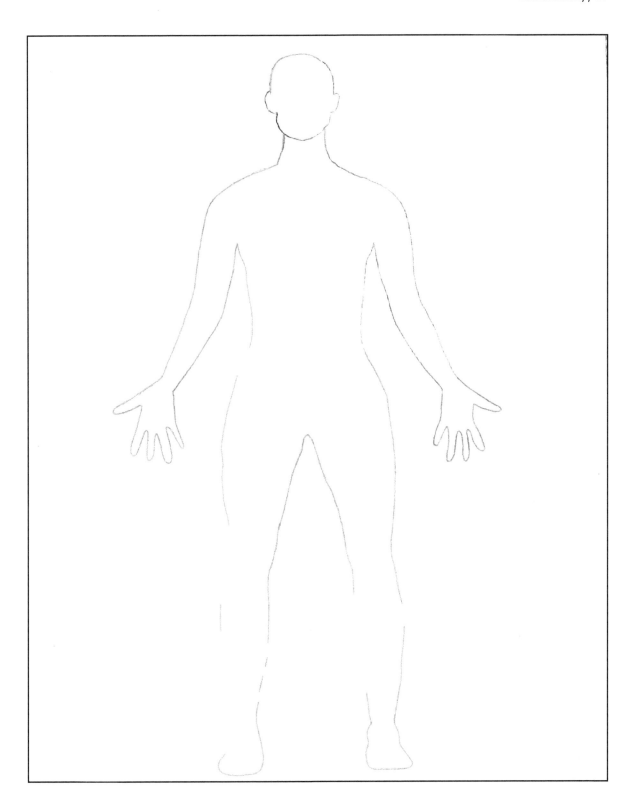

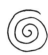

CHAPTER SIX

AN INTRODUCTION TO AURAS

The recognition of auras dates back to ancient Egyptian art and is referenced throughout history in many cultures. In a 1945 essay, psychic healer, Edgar Cayce wrote that he believed all things give off energy and have an aura. Cayce's writings generated interest in spiritual experiences and information, including information on the aura. Cayce's work directly impacted and contributed to what we know as "New Age" philosophy and is still widely cited today.

What is an Aura?

Everything carries its own vibrational signature. Within that signature, low-level electricity known as the electromagnetic field or aura radiates. This energy field appears as a soft glow around the physical body or object. Some people can even discern different colors in the auric energy field. Ancient medicine systems place spinning vortices or wheels at the center of the energetic system, acting like generators. These generators are called **chakras**. Think of the aura as a representation of the physical body, and the

chakras as a representation of the organs. In this book, we'll look at seven different chakras, but there are more than these.

The aura is often compared to an onion with layers wrapping around the physical body. Through my clairvoyance, the aura looks like a sticky substance. Sometimes, I sense up to seven different layers or subtle bodies.

First Subtle Body

The first subtle body relates to the physical body. It is referred to as the etheric body. The etheric body is closest to our skin and holds information about our tissues, muscles, and bones. The etheric body is connected to the root chakra.

Second Subtle Body

The second subtle body is the emotional body. The emotional body is part of the aura tied to our feelings and emotions. This layer of the aura expresses a rainbow of color changes and is most often represented through different media, such as artwork or Kirlian photography. The emotional body is connected to the sacral chakra.

Third Subtle Body

The third subtle body is the mental body. The mental body holds information about how we use our logic, solve problems, and mentally reason. It helps filter our ideas and beliefs. The mental body is connected to the solar plexus chakra.

Fourth Subtle Body

The fourth subtle body is the astral body. The astral layer is responsible for recording all the information on our experiences, relationships, childhood, and past lives. Almost all healing energy comes through the fourth subtle body, which is associated with the heart chakra.

Fifth Subtle Body

The fifth subtle body is referred to as the "template" and includes everything you manifest on the physical plane, including your identity, personality, chosen life path, and overall energy. The fifth subtle body is connected to the throat chakra.

Sixth Subtle Body

The sixth subtle body is the celestial body. This is where we receive information through dreams and intuition. It's taught that highly creative people have a strong connection to the celestial plane. The celestial body is linked to the third-eye chakra.

Seventh Subtle Body

The seventh subtle body is also called the causal body. It's responsible for balancing all the other layers and guides us along our life's purpose. The causal body is linked to the crown chakra.

When we work with **Chakragraphs**, we tune into all the subtle bodies of the auric field at the same time and with their respective chakras. Gathering information from each subtle body gives a well-rounded, informative reading about every layer of that human's existence. It sounds really big, but the process is effortless and unfolds naturally in the Chakragraph process.

What is a Vibration or *Vibe*?

Your vibe is the rate at which your electromagnetic field, or aura, vibrates. Lower vibrations tend to feel denser, thicker, and heavier, whereas higher vibrations feel lighter, more energizing, even contagiously happy. We tend to feel most comfortable around those whose auras vibrate at a similar rate to our own.

The Clair Senses

On Page 22, I explained different types of clair senses that a person can work with to intuit extrasensory information. There are no hard and fast rules on psychic senses. Some people work with many clairs at the same time. Then, some only work with one or two primary clairs throughout their entire lifetime. It's important to know that more clairs does not equal more extraordinary talent or better results. A practiced gift of clairaudience can provide more detailed and reliable information than someone who has seven clair senses and doesn't acknowledge or work with any of them.

Know that everyone carries at least one clair sense in their make-up. However, not everyone chooses to work with them. You will work with your unique clairs to read your Chakragraph charts, even if you're unsure of what talents you have right now. Over time, you'll learn which clairs you possess and may even discover new ones. clairs have a way of developing one at a time, so it's completely normal to have one clair shift into another. Allow them to flow, and don't try to force them into being. Through consistent practice, you'll soon learn to trust what comes naturally to you.

Channeling

One of the most common questions I receive when teaching a Chakragraph workshop is, "How can I create a clear channel for my intuition?"

First, let's discuss what a channel is. A spiritual channel is a person who syncs with the frequency of the universe and obtains information from the Spirit world.

It might be helpful to think of a spirit channel as a radio. The static of the radio is like the average frequency of the human mind. It's busy, full of distortion, and very noisy. When we channel, it's like turning the radio dial to stop on a station. Suddenly all the static is gone, and we have beautiful clarity!

Each of us has the ability to channel. Think of a time when you've been trying to generate an idea for months. Then, suddenly the answer pops into your mind when you are relaxed and focused on something else, such as taking a shower, doing the dishes, or driving your car. You're a channel when an art piece practically paints itself. Or when a poem or song pours out of you, and it's as perfect as it can be.

When we are clear channels, we receive support through sudden ideas and inspiration. Answers are delivered to assist with our problems or challenges, including inspired writing, music, and art. As a clear channel, the Divine fills us with a sense of calm, groundedness, and peace.

Recently, I spoke to a woman who woke up in the dead of night with an idea for a children's book. ("It came out in a rhyme," she said. "And I don't rhyme!") She ran for a pen and paper, and her thoughts poured out of her. In a few hours, she allowed her book the space it needed to be born. Now, it's a lead title for one of the biggest children's book publishers in the world. When we channel, whether it's for advice, artwork, books, inspiration, or problem-solving, Spirit is there and loves to help!

The Chakragraph System helps us navigate through the noise and static of the mind and works in harmony with our inner radios by turning the dial to clear energy channels. By working with this system regularly, you will quickly tap into Universal/Source energy. You'll build trust in the Universe and your Spirit Helpers, and gain confidence in yourself.

How the Aura Responds to the External Environment

The aura acts as a mediator between the physical and non-physical worlds. The non-physical worlds are the higher dimensions and spiritual planes that exist, but most of us cannot see them with the naked eye. We are in constant interaction with these dimensions, even if we don't recognize them.

The aura is dynamic, meaning it both receives and releases information, which is how our thoughts, prayers, and intentions manifest into form. Some people are extremely sensitive (also known as "empaths") and can absorb other people's emotions into their own aura. For example, an empath enters a crowded space feeling energized and excited, only to leave the space feeling drained and exhausted an hour later. The empath absorbed the energy of the room, and maybe the emotions of people who were near. Another way to picture an empath is like a dry sponge placed in a dish of water.

Aura absorption happens with homes, animals, landmarks, possessions, and land. Everything carries its own unique vibration. We can "pick up" information on that vibration with our clair senses by paying attention to how our body senses and responds to the environment.

Sometimes while walking through public places, such as restaurants or grocery stores, we begin to feel a dramatic shift in our emotions that we weren't experiencing before. Accidental aura absorption can cause the empath a great deal of mental, emotional, and physical distress.

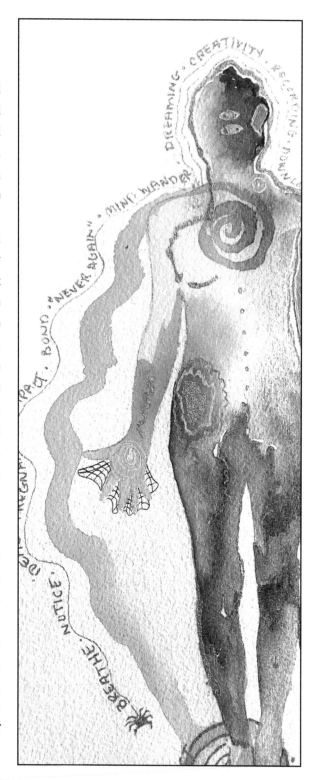

On the other hand, if someone has a higher or harmonious vibration, an empath feels comforted, witnessed, and balanced in their company.

Exercise: How to Sense Your Aura

In this quick exercise, we'll practice sensing our own aura.

Place the palms of your hands together and rub them vigorously. Slowly pull them apart and bring them back together. As you do this, you'll begin to feel resistance. That resistance is your aura. The closer your hands are together, the stronger the sensation gets. The farther your hands are apart from one another, you'll notice the feeling lessen.

Those interested in seeing auras, grab a friend and have them sit or stand in front of a light-colored wall. Soften your gaze and look toward the area of their left shoulder. You'll soon begin to make out a faint, hazy outline that follows the shape of their body. Sometimes you can even see different colors start to take form. This is their aura.

Practice this same technique with yourself by raising your hand toward the ceiling. Again, soften your gaze until you see a soft light begin to outline your hand. For many, lighter colored backgrounds tend to work better than darker ones but practice with both to see what works for you.

How Chakragraphs Help Strengthen and Heal Your Aura

Auras are fluid and malleable. They are dynamic fields of energy and need to be detoxified and cleared like our physical body.

Without regular care, an aura's strength weakens over time. They can tear, get holes, and even suffer from intrusions. We are responsible for maintaining our spiritual health, just as we are responsible for our physical health. While some scars we carry for a lifetime (and even over many lifetimes), we can prevent and repair a lot of what occurs by paying attention to how our bodies respond to specific situations and taking preventative measures to care for our spiritual body.

Think of it this way, if you were to fall and scrape your knee, you would clean the wound, put on an antibiotic ointment, and maybe even a Bandaid. We can do the same thing with our aura. For example, suppose you had a bad encounter with someone that leaves you feeling sad or upset. In that case, you can smudge your aura using a sacred plant such as rosemary or juniper to clear the energy of the incident and carry a rose quartz crystal to help soothe the pain and raise your heart's vibration.

Here are a few examples of how I clear my aura:
- Smudging with herbs, such as rosemary, juniper, or mugwort
- Spritz a clearing spray using Himalayan salt and plant essential oil
- Meditation
- Shamanic journey
- Sound baths, drumming, singing, using a singing bowl, crystal bowl, or ringing a bell
- Salt baths or sitting in a salt cave
- Using a pendulum
- Prayer
- Journaling

Aura healing requires us to be responsible and routinely sit, be still, and go inward to hear what stories the body, mind, heart, and soul have to share. The moment we realize something is an issue, we are responsible for mending it, unwinding it, resolving it, or letting it go.

In part, this is what makes the Chakragraph process so valuable. Chakragraphs offers a new way to perceive oneself through a playful medium like watercolor. It helps us translate the voice of the inner world. Work with your reading results to concentrate your energy on healing the emotional, physical, or energetic imbalances revealed in the subtle body system. The Chakragraph System is a beautiful ally to

psychotherapy practices, Reiki, Epsom salt baths, meditations and visualizations, dance and yoga, and even crystal therapy. We have the right and responsibility to reclaim our spiritual health and wellness!

CHAPTER SEVEN

COLOR

Color is all around us. The way we look at color reshapes the way we look at life. The six colors used in Chakragraphs are warm, meaning they have undertones of yellow, orange, or red. If you'd prefer to work with a palette of cool colors, you'd look for paints that have undertones of green, blue, or purple. See Page 32 for the paint color names.

Warm colors tend to create energetic and cozy portraits, whereas cool colors appear as soothing and fresh. Warm or cool color palettes are a matter of preference. I chose this warm palette for how inviting the colors feel and how nicely the colors mix and work with one another.

Aura Colors and Their Meanings

Each aura color has an interpretation inspired by contemporary color psychology, my personal experience and emotions tied to the color, and through my work with Spirit. Throughout this process, allow yourself to develop your color language alongside the interpretations I offer. There are no steadfast rules. Pay attention throughout your practice to how particular colors make you feel and what they bring to mind. Your emotions, sensations, or color associations may be vastly different from mine—that's okay!

I encourage you to find a color language that's your own. If you feel the following information fits your understanding or beliefs, then that's fine, too! There is no right or wrong way to create your color dictionary. All that matters is that your meanings make sense to you.

Throughout the artistic process, many of us won't "see" our colors with our eyes or in our mind's eye before we begin painting. Please put your trust in the process. The only way you're going to get an inauthentic color is if you try to manipulate the outcome to what you *think* is correct.

For example, say your friend agreed to let you paint her Chakragraph. You've created sacred space. You have all your materials ready. Now, you're going to paint. The color you're immediately drawn to is black. *I can't paint her aura black!* You think. You know your friend is very intuitive, it's something you admire about her. So you choose the color purple instead.

While technically, your forced purple answer is correct, what you didn't know is that your friend has been going through a significant life transition and was let go from her workplace after three decades of service. By choosing the color you felt comfortable with rather than the color Spirit was sending, you limited the Chakragraph's potential to read your friend in a meaningful way. Your first impression is always the correct one. It's up to you to trust it and follow through with the suggestion. The colors don't lie.

Color Dictionary

Here are the colors that routinely come up in Chakragraphs and can be created by mixing the six colors provided in this book. Light color variations appear when the color has more water, and vivid colors happen when the color is saturated with paint. What do these variations mean to you? You can create your own color dictionary by painting a color mixing chart or painting each of your color mixes in an art journal and documenting your formulas and interpretation of that color. Each practice is a little extra work but well worth the effort.

Light Pink: Points to someone with a sensitive heart and a gentle disposition. It's the color of motherhood, care-taking, tenderness, innocence, softness, and love. When I see someone with a predominately pink aura, they are a caretaker for others in their home, family, or community, are tenderhearted, loving, and gentle.

Bright Pink: Love. Sincerity. Passionate. Friendship. A true humanitarian spirit. Bright pink livens up the aura and speaks of someone willing to take action and make sacrifices in the name of equality and love.

Dusty Rose: Contemplation. Reflection. Sometimes dusty rose points to codependent behaviors or someone repeatedly refusing what their heart longs for.

Terra Cotta: Terra cotta is a color that denotes career changes or shares when someone is learning to accept or adapt to a recent change.

Bright Red: Power, energy, strength, authority, and action. Red is a color of empowerment. It's where intimacy turns into passion and energy turns into strength. Red is an intense color and shows where we have invested our faith in ourselves and our abilities, and are emboldened into action.

Maroon or Deep Red: This can point to aggression or anger, fear, or an inability to see past one's emotions. This color shows us where there may be an energetic or emotional imbalance due to unresolved anger.

Red-Orange: Indicates intense creative fire, power, ambition, and drive.

Bright Orange: Self-control. Ambition. Courage. Creativity. Sexuality. Emotions. Optimism. Success. Orange is a color of motion and emotional depth.

Burnt Orange: Indicates trials in learning self-control and self-discipline. Sometimes it points to old emotional weight coming to the surface to be witnessed and let go.

Brown: Friendly. Warm. Earthy. Lover of the outdoors. Healed by nature. Brown is a very dependable, comfortable color that expresses when someone is grounded, talented, and capable of overcoming the tasks and challenges that lay ahead.

Dark Brown: Strong common sense and practicality. Indicates someone who is firmly grounded. Dark brown suggests extra discipline is needed now. If there is a lot of dark brown, especially in the hands or the head, sometimes this points to rigidity, or an unwillingness to yield to other ideas or change.

Yellow Ochre (Yellowish-Brown): Excessive thinking, feeling stuck, feeling isolated, lonely, and/or may be in a period where one is experiencing low self-esteem.

Canary Yellow: Optimistic. Happy. Intellectual. Friendly. Bright. Mental stimulation. Integrity. Clear decision-making skills. Personal power. Confidence. A planner and thinker. Canary yellow shows up in our life when we are gaining strength in our character, when we feel empowered, encouraged, supported, and strong. Canary yellow shows our learned ability to separate ourselves from old labels or stories we've assigned to ourselves, but that no longer serve us.

Lemon Yellow: Indicates problems with our self-confidence. Lemon yellow shares where we're feeling worried, that we're over-thinking, experiencing scattered thoughts, feeling fearful, and suffering from anxiety.

Spring Green (Yellow-Green): Spiritual growth and new beginnings. Excitement for what's to come. Spring green often indicates an energy reset or feeling like one has "come up for air" after a challenging experience or period in their lives.

Bright Green: Money. Income. Finances. Growth. Fertility. Freshness. Healing. Generosity. Love of nature. Bright Green is a grounding, soothing color that indicates harmony, prosperity, and unconditional love.

Muddy or Olive Green: Indicates deep grief, sadness, feeling fearful, uncertain, or experiencing jealousy. Feeling a sense of loss or regret.

Aqua: A healer/healing energy. Indicates someone who easily inspires others. Denotes a natural leader born with grace and humility. An omen of an advantageous time to embrace alternative healing modalities or therapies.

Light Blue: The color of sensitives, artists, writers, and poets. Light blue points to the dreamers and the deep feelers.

Bright Blue: Communication. Self-expression. Depth. Intuition. Clarity. Blue is a color of expression, tranquility, wisdom, and truth. A lot of blue in the aura can indicate a person with rich communication skills, oral or written, and may have chosen a vocation or hobby that utilizes their talents well. Blue at the core of the body can symbolize a person who is attuning themselves to their integrity and truth.

Muddy Blue: Problems with using one's voice or honoring one's true path. Muddy blue can show up when we've lost our ability to communicate our needs, desires, or feelings honestly, or when we're feeling unsure of our true purpose.

Gray-Blue: Problems with using one's voice. Can indicate a vocal block or imbalance of some sort, or an inability to speak one's heart, truth, and mind. Gray-Blue showing up in the throat sometimes points to a person experiencing the symptoms of a thyroid imbalance or chronic fatigue.

Lavender/Light Purple: Spiritual awareness. Gentleness. Kindness. Humility. Lavender often points to someone who has become aware of their spirit and spirituality.

Bright Purple: A visionary. Spiritual awareness. Dreaming. Higher consciousness. Sensitivity. Purple is a playful, magical, humble, and cheerful color that expresses the power of mystery, Spirit, and the imagination.

Mauve: Marks the end of a period of obstacles or challenges. Denotes working through the challenging places in life and choosing to move on and move forward.

Deep Purple: Deep psychic energy, sometimes going back generations. Lucid dreaming. Prophecy. Visitation dreams. **Seer**.

Brownish Purple: Indicates a blocked third-eye chakra, lack of dreaming, or being out of touch with one's intuition.

Gray: Blocked perceptions. Depression. Shame. Guilt. Deep remorse.

Black: Protection, transition, change. Black is a shade that shows up in the aura during a period of emotional growth, change, or evolution. Sometimes, this is a sign of a significant trial.

Chakras and Their Colors

Chakra is a Sanskrit word that means "wheel." Your life-force energy (**chi** or **prana**) is continuously spinning and rotating inside you. Chakras are the main energy centers of the body that our life-force energy flows through. They are in constant motion, like colorful pinwheels spinning on a stick. The strength of the spin varies with each chakra. With Chakragraph readings, focus your attention on the colors that show up in each chakra to learn about a person's balanced or unbalanced energy.

- Energetically balanced colors look clear and clean.
- Overactive energy colors appear vivid or oversaturated.
- Underactive energy colors appear weak or desaturated.
- Blocked or unbalanced energy colors appear darkened or muddy.

Read more about the Chakras and their connection to the Subtle Bodies on Page 56.

Here is more information about chakra energy to get you started.

Root Chakra
Color: Red

The root chakra is located at the base of the spine. In the Chakragraph charts, the root chakra begins at the tailbone and extends through the legs. The root chakra governs our ability to feel confident and secure in our lives and what we've built for our life's foundation. The root chakra helps us withstand challenges and obstacles that come our way.

A balanced root chakra creates independence, has stable resources, brings a sense of security and accomplishment.

An unbalanced root chakra creates trouble concentrating, an "ungrounded" feeling, encourages frequent daydreaming, initiates a flight or fight response, and a sense of being unsafe or unstable.

Sacral Chakra
Color: Orange

The sacral chakra is located in the lower abdomen and pelvis, about two inches below the navel. The sacral chakra governs our emotions and our empathy for others. It also governs our creativity and sexuality.

A balanced sacral chakra feels creative, helps us solve problems, encourages healthy sexuality, has a strong sense of emotional connection to others and ourselves, and help us experience pleasure.

An unbalanced sacral chakra creates apathy, gluttony, and an inability to connect with other people emotionally.

Solar Plexus Chakra
Color: Yellow

The solar plexus chakra begins at the navel and goes upwards into the chest center where the two halves of our ribs connect. The solar plexus chakra houses our self-confidence, identity, and personal power. The solar plexus chakra is where our inner wisdom is born.

A balanced solar plexus chakra feels empowered and connected to our inner wisdom. It helps us be decisive, confident, and live with a strong sense of integrity and personal truth.

An unbalanced solar plexus chakra creates a feeling of disconnection, makes us feel as though we lack a connection with others or our identity, have digestive issues, are quick to anger, express greed, lack empathy, or feel insecure and timid.

Heart Chakra
Color: Green

The heart chakra begins at the heart center and radiates between the breastbone and the throat's base. The heart chakra is responsible for helping us feel love for others and ourselves. The heart chakra is the vortex that connects the upper chakras (the heavens: throat, third-eye, and crown) to the lower chakras (the physical world: solar plexus, sacral, and root).

A balanced heart chakra feels love, compassion, kindness, and a sense of human connectedness and gratitude for others.

An unbalanced heart chakra feels codependent, isolated, lonely, fearful, out of touch, and out of reach to others.

Throat Chakra
Color: Blue

The throat chakra is located in the throat and radiates into the collarbones and up through the nasal passages. It governs our ability to express ourselves authentically, communicate our truths, and say how we feel. The throat chakra is where we choose our vocation.

A balanced throat chakra speaks kindly and compassionately, knows precisely what to say and when to say it, speak our truths without fear and embrace who we really are.

An unbalanced throat chakra is disconnected from our words or sharing, from our vocation, and living our highest purpose.

Third-Eye Chakra

Color: Indigo

The third-eye chakra is located between the eyes and radiates between the sinus passages and into the mouth and extends up to the top of the head. The third-eye chakra governs our intuition, dreaming, intuitiveness, and psychic energy.

A balanced third-eye chakra feels in sync with the physical world, receives balanced psychic information, and easily accesses greater wisdom outside of oneself while providing rich and vivid dreaming.

An unbalanced third-eye chakra feels overwhelmed with psychic energy and by extra senses and too connected to other people's emotions or impressions. It can become engrossed in the occult or different spiritual experiences to the point where one isn't living a physical life.

Crown Chakra

Color: White or purple

The crown chakra connects us to a greater universal collective consciousness. It is located at the top of the head and extends upward and outward into the universe.

A balanced crown chakra feels humility, wholeness, bliss, clarity, and connectedness.

An unbalanced crown chakra feels depression, alienation, a lack of direction, and disconnected spiritually.

What is Imbalanced Energy?

Imbalanced energy is the manifestation of an emotion created from an event or experience that hasn't been cleared, released, or processed and has stagnated in the energetic signature (aura) or the subtle body (chakras).

Spirit asks us:

If something is stuck in our subtle body and the physical body is the container, how do you think it affects the health and quality of that container?

Food is fuel to the body.

Light is fuel for the soul.

How efficient do you think we can cycle light if we have imbalances in our energetic system?

How do you think that affects the health of our mind, confidence, spirit, or our ability to love?

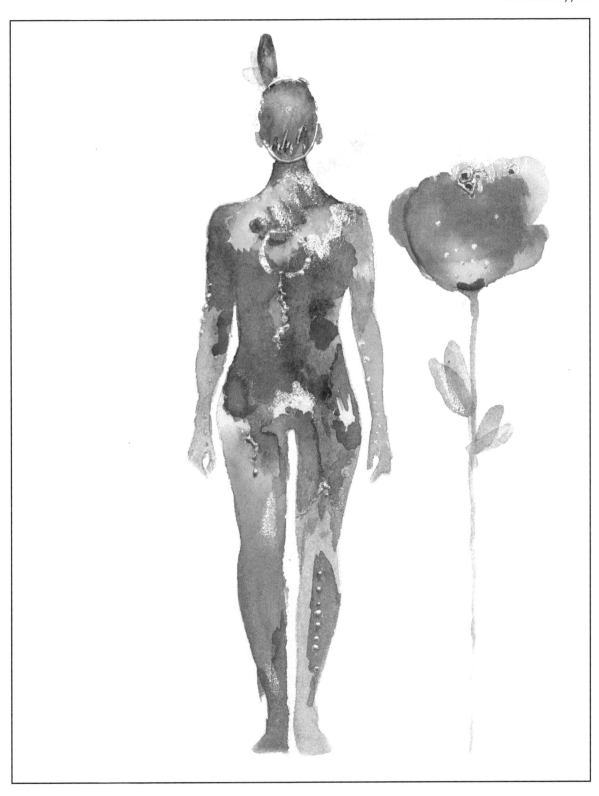

CHAPTER EIGHT

HOW TO PAINT A CHAKRAGRAPH

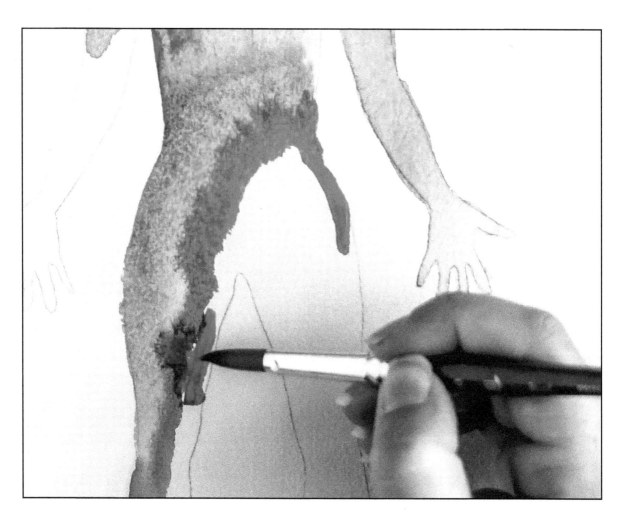

So far, you've been introduced to the supplies needed (See Page 30), learned about creating sacred space (See P 79), learned a few foundational brush strokes (See Page 42), were introduced to the color dictionary (See P 66), and opened the doors to learning about auras and chakras (See Page 56). Now, it's time to paint and work with an actual Chakragraph. There are a few things to keep in mind as we begin:

1. Your painting style changes and grows as you do. Just as I began with ink and ended with watercolor, you may shift and change in your artistry, too. Try to release any judgment you may have about your skills or materials. If the information you've been reading in this book is the seed, your first Chakragraph will be the seedling that rises from what you've learned. Please take care of it. Love your paintings for what they are. You can "water" and nurture your skills through the act of practice and play.

2. The intuitive hits or intuitive information that you receive in the beginning may be very different than the information that moves through you later. As you continue to practice, your process will grow, too. Your knowledge will increase, become more refined, and will be easier to access. Practice, practice, practice!

3. Keep notes in an accompanying journal. I recommend purchasing an art watercolor journal (Moleskine is a great brand for this purpose) to transfer your paint colors and any symbols or marks that may come up in your paintings. This provides a quick point of reference that you can quickly come back to over and over.

4. Most importantly, please remember that you've chosen this process for a reason. However you came across this book, it was not a coincidence or accident. Trust that you have everything you need within you to be successful.

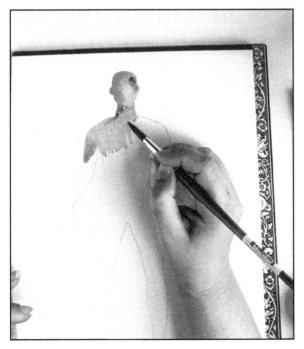
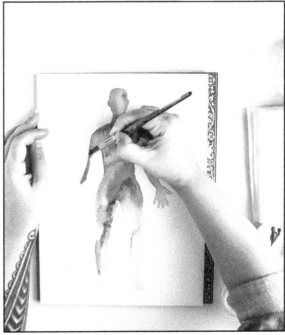

Painting a Chakragraph Step-by-Step

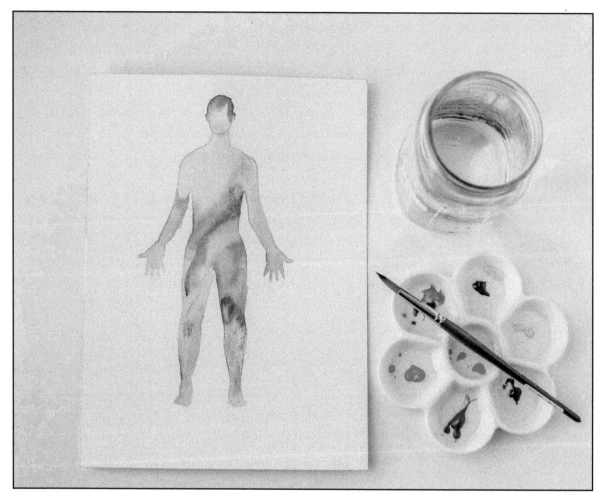

Materials needed:

- Printed Chakragraph template
- Graphite paper
- Watercolor paper
- Pencil or ink pen
- #10 round watercolor brush
- Watercolor paints: purple, red, yellow, blue, brown
- Mixing tray
- Two jars of water (one for clean water, one for cleaning brushes)
- Paper towel or a lint-free cloth for blotting your brush or lifting color

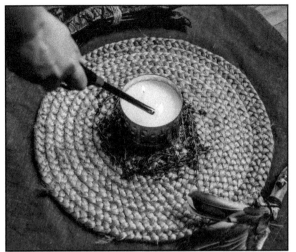

1. Open Sacred Space. Meditate. Say a prayer. Call in your helping ancestors, your spirit team, or settle into yourself and your space by being still for a moment. Enjoy the quiet, music, or the sounds of your home or office. Focus on your intent: why do you want to paint today? What is your intended outcome? It can be as simple as: *I intend to paint my true self.* Your intention doesn't have to be a big, bold gesture. All that matters is you connect to what you're saying.

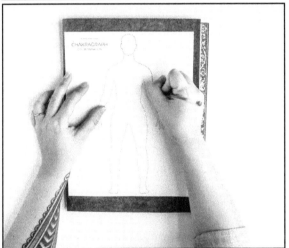

2. Transfer Your Template. Just as we practiced in Chapter 4, lay your tracing paper with the graphite side down against the watercolor paper. The lighter color should be facing up. Next, place your printed body template on top of the graphite paper and trace around the figure to transfer the image. Try to hold both papers tight to avoid any slippage. Use painter's tape if you need to. When you complete the transfer, take note of any missing pieces and any intuitive impressions.

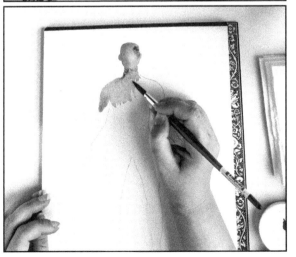

3. Begin to paint. Whether you take your time or paint very quickly, allow the flow to occur organically. Remember, this process is meant to be fun! If you're not having fun, reflect on what's preventing you from enjoying the process.

4. Let dry. Watercolors lighten as they dry, causing your colors to soften considerably. Begin to read the Chakragraph once you feel the painting has dried. Make notes of any intuitive hits you have while painting.

Note: You can tell if your painting is wet or dry by touching the artwork. If your paper is cool to the touch, it's still wet. If your painting is warm, it's dry.

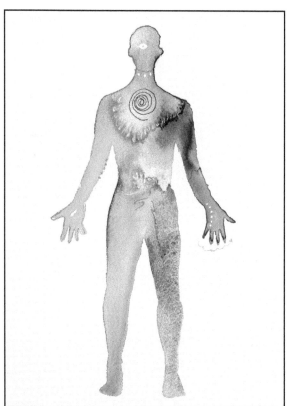

5. Add embellishments. You may feel called to add symbols. Keep a record of what you use in your color and symbol journal. You don't have to add embellishments, but try not to overthink it if you choose to. If a heart wants to be in the crown chakra, let it be there. If a line wants to be struck through the heart, put the line through the heart. Remember, this is a practice of sacred communion with Spirit. Be a clear channel for your Guides and let that wisdom come through you and onto the paper. This is the biggest challenge for many—to let the information flow.

Note: Symbology information is on Page 92.

6. At some point, your painting will feel done. Allow it to rest and marvel at your creation! Then, begin your reading.

CHAPTER NINE

READING THE BODY

Reading a Chakragraph may feel familiar and comfortable, or it may take time to step into and embrace. Please remind yourself that this is not a practice that depends on being a gifted artist or psychic. Your job is to make the art and deliver those interpretations to yourself or others with compassion and have fun! I genuinely believe that if you stick with it, you'll make connections between the body art and colors. You'll naturally begin to "see" things that are in alignment with your specific talents and gifts.

Know that every single person will intuit different information. One person may receive information on the physical body; another may be more aligned to read emotional trauma or a past-life story. Another person may read both! There are limitless possibilities, so don't try to pigeonhole yourself into a specific category. The goal is to feel your way through the process and take time to learn your unique way of interpreting the artwork.

The body helps us understand how emotions store themselves. The definitions came from information I learned through Chinese medicine, the excellent work of Louise Hay and Cyndi Dale, Usui Reiki, and my Spirit Team. You may have different interpretations of what emotion gets stored in the body and why, so please swap my definitions for your own. Use your skill sets, knowledge, and wisdom. And as always, work with what feels right to you.

Tale of the Two Sides: The Dreamer and The Doer

In my charts, each area of the body holds a specific meaning. There are two sides to every interpretation, just as there are two sides to every story. The left side of the body symbolizes Yin energy. It's the dreamer's energy, the feminine, nighttime, autumn and winter; the intuition and inner psyche. Yin energy holds information about our experiences and our past, the memories of our joy and pain. It represents the emotional self, our softness and receptivity, helps us understand ourselves better and makes sense of our experiences. Information on the left side of the body often relates to the past. It also holds information about what we have yet to speak out loud, haven't entirely made sense of yet, or shared with others.

The right side of the body is Yang energy. It holds the energy of the doer, analyzer, masculine, and builder. It is the sun and sunshine, spring and summer, external, and logic. It is our directness

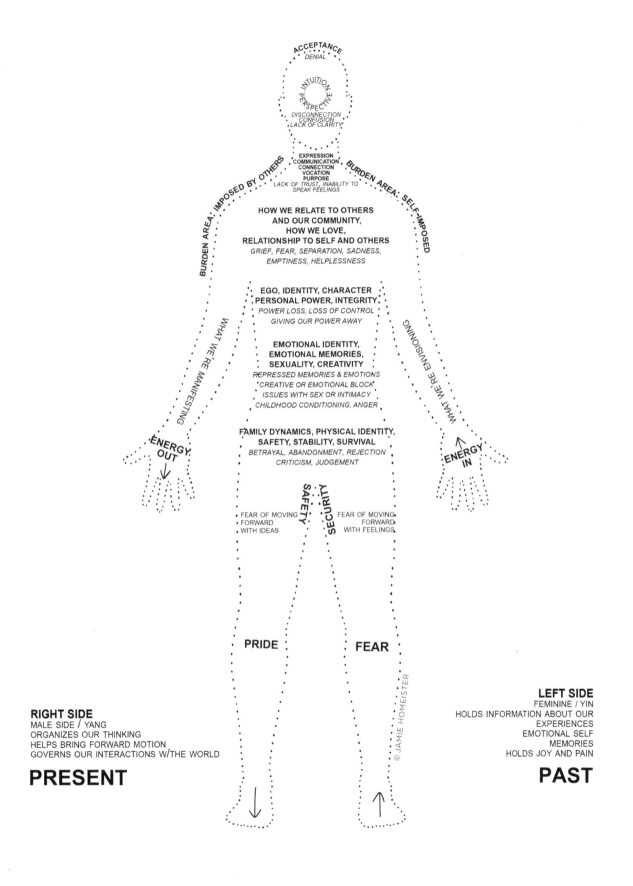

and activity, movement, and choice of action. Yang energy holds information about our thinking and shares how we put our thoughts and dreams into motion. When information comes up on the chart's right side, some part of that emotion, action, or movement is already in effect, witnessed, or otherwise recognizable. It symbolizes what's happening now and possibly the near future.

Making Sense of Our Lefts and Rights

Whether I am reading for myself or someone else, in my mind's eye, I always see the person I'm reading as if they are facing me and we're having a conversation. Therefore, the left-hand side (Yin) of the painting represents the right-hand side (Yang) of the body. The right-hand side of the painting represents the left-hand side of the body, but render your charts in the way that makes sense to you.

Body Area Interpretations

Standard definitions are read as clean, clear colors that are bright and without marring. Colors that have turned muddy or clear colors with intrusive elements represent reversed meanings or imbalanced energy. We can use body interpretations to identify the greater purpose of the colors we're seeing.

For example, what if canary yellow appears in the artwork on the left-hand side of the temporal area? Canary yellow is a color of joy and optimism (see Page 66 for Color Dictionary), while the left-hand side of the temporal represents our courage to see ourselves truthfully. If I put the two concepts together, I could say that the person in my artwork feels optimistic and even joyful about their self, and sees the self and their life from a truthful space.

If the color were gray instead of yellow, I could read that this person may see themselves through a distorted lens.

Crown

Location: The Crown is at the top of the head, radiating from the top of the skull and beyond.

Balanced Energy: one may feel or experience acceptance, honor, spiritual integrity, trust, surrender, lucid dreaming, vision, clarity, spiritual connectedness, focus, determination, creative energy, and/or mindful presence.

Imbalanced Energy: one may feel or experience a lack of trust in Divine timing or trust in oneself, a learning of surrender to greater flow or forces of circumstances, confusion, frustration with current circumstances, apathy, headaches, pressure at the top of the crown, isolation, ungroundedness, "losing one's head," or depression.

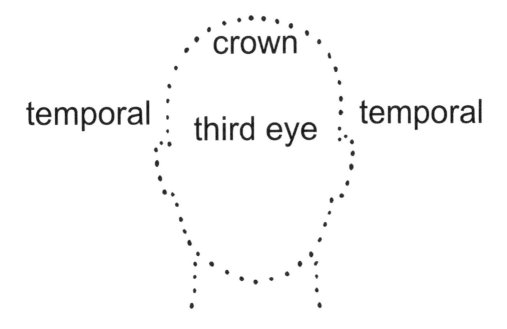

Third-Eye

Location: The Third-eye is located between the brows and radiates through the upper sinus cavity to the top of the head.

Balanced Energy: one may feel or experience visions of the future, an open and clear perspective, inner wisdom, heightened sixth-senses and intuition, imagination, seeing beyond the obvious, a higher consciousness, a deeper focus, a creative energy, and/or motivation.

Imbalanced Energy: one may feel or experience trouble sleeping or staying asleep, frequent headaches, indecisiveness, fear of the truth or the unknown, a lack of imagination, or confusion, frustration, or uncertainty with what to do with one's life.

Temporal

Location: The Temporals are located at the temples on either side of the head.

Balanced Energy: one may see the world truthfully (Right/Yang) or see oneself honestly (Left/Yin).

Imbalanced Energy: one may feel or experience temporal headaches or have an unwillingness to look at oneself (Left/Yin) or one's life (Right/Yang) openly, objectively, and truthfully.

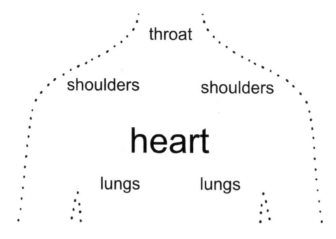

Throat

Location: The Throat covers the jawline, tongue, teeth, lips, lower sinuses, esophagus, occipital bone, and thyroid.

Balanced Energy: one may express one's authentic truth, communicate thoughtfully and clearly using words, art, music, journaling, therapy, or any means of personal expression, connect to oneself and others through one's voice, listening, or the written word, speak mindfully and truthfully, feel unafraid to share one's true self, have a heightened sensitivity to Spirit, work in a vocation that fits one's goals, skill sets, and talents, or is attuned to one's purpose.

Imbalanced Energy: one may feel or experience trouble expressing oneself, a sore throat, repressed anger, a blockage or stifling in one's voice or as if one "can't find the right words," resentment, guilt and judgment, indecisive, or hearing problems.

Shoulders

Location: The Shoulder area includes the left and right shoulder, trapezius muscle, clavicle, and scapula.

Balanced Energy: one may focus on a career or main hobby (Right/Yang), or goals and aspirations. (Left/Yin).

Imbalanced Energy: one may question if one's work aligns with their goals, talents, or purpose, feel unrewarded or uninspired in one's work, or carry other's pains, sorrows, or burdens (Right/Yang), or experience limitations and burdens imposed upon oneself (Left/Yin).

Heart

Location: The Heart area is slightly left of center in the upper chest.

Balanced Energy: one may feel or experience compassion for others and self-compassion, love, trust, acceptance, forgiveness, gratitude, kindness, integrity, generosity, and/or peace.

Imbalanced Energy: one may dwell on past mistakes or relationships, hold onto past hurts or grudges, have abandonment issues, criticize others or oneself, feel isolated, lack empathy, experience emotional pain, feel codependent, experience rejection, jealousy, and/or feel judged by others or oneself.

Lungs

Location: The Lungs are centered in the upper chest.

Balanced Energy: one may feel or experience clear thinking, be open to change or new ideas, be able to go with the flow, or have good communication skills.

Imbalanced Energy: one may carry a lot of residual grief or sadness, be learning how to communicate, feel uninspired by new ideas and perspectives, or find it difficult to accept change.

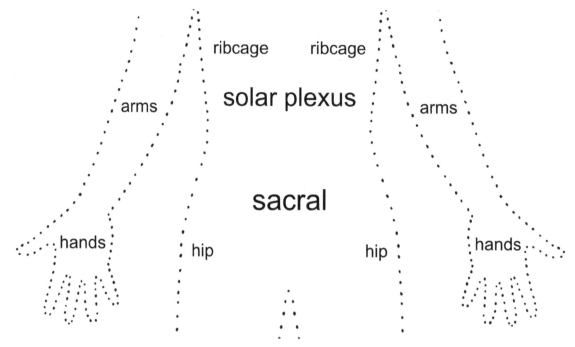

Ribcage

Location: The Ribcage is in the upper chest.

Balanced Energy: one may feel or experience safety, structure, security, or support.

Imbalanced Energy: one may feel unsafe, ungrounded, uprooted, or insecure, lack formal routines or structures in one's life, or that one lacks the ability to emotionally or physically support others or oneself.

Arms

Location: The Arms include the upper arms, elbows, and forearms.

Balanced Energy: one may feel or experience an opening of oneself to new ideas, projects, beginnings, and inspiration (Left/Yin), implement new strategies, enforce changes, and/or use one's resources in the world (Right/Yang).

Imbalanced Energy: one may have a hard time dreaming up, conceptualizing, or implementing new changes, wishes, or plans (Left/Yin), or may experience difficulty focusing on projects, completing goals, or finishing projects (Right/Yang).

Hands

Location: The Hand area includes the wrist, palm, and fingers.

Balanced Energy: one may know what one is building, implementing, and/or giving (Left/Yin), or what one is dreaming, conceptualizing, and/or accepting (Right/Yang).

Imbalanced Energy: one may be learning to grasp new ideas, beginnings, or opportunities, how to accept help, experience gratitude on deeper levels, and/or connect intimately with others.

Solar Plexus

Location: The Solar Plexus includes the navel and above navel into the chest cavity where ribs first come together.

Balanced Energy: one may experience a healthy self-identity, personal power, self-confidence, self-love, self-esteem, motivation, a strong sense of personal responsibility, and/or clear decision making.

Imbalanced Energy: one may experience low self-esteem, anger, ask questions like "Who Am I?" or wonder about one's life purpose, and/or feel as though one is not living through one's personal power.

Sacral

Location: The Sacral area includes the pelvis.

Balanced Energy: one may feel or experience joy, compassion, inspiration, and safety to express oneself, forgiveness, sensuality, emotional maturity, and a healthy relationship with sexuality and pleasure.

Imbalanced Energy: one may feel or experience a block or decrease in creative energy, judged by others or self, unstable emotions, emotionally withdrawn from others, and insecure, fearful, or a lessened sex drive or unhealthy pleasure-seeking behaviors.

Hips

Location: The Hip area is on the outer edge of the sacral area.

Balanced Energy: one may check-in with Self to make personal, inner changes (Left/Yin), or be able to make level-headed and clear decisions in the external world (Right/Yang).

Imbalanced Energy: one may be unable to make decisions, blocked by circumstances or the environment, or unable to progress, blocked by the inability to make a choice or lack options to move on.

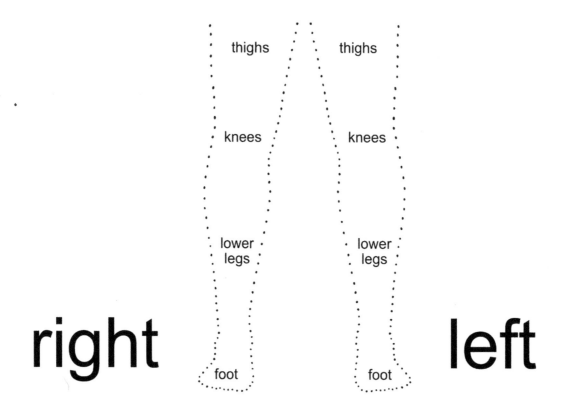

Thighs

Location: The Thighs include the inner and outer upper, right and left legs.

Balanced Energy: one may experience healthy relationships with family, friends, and Self, feel safe to implement one's boundaries in relationships.

Imbalanced Energy: one may experience relationship fatigue, unable to maintain healthy relationships, lack boundaries with others and oneself.

Knees

Location: The Knee area is in the middle of both legs.

Balanced Energy: one may feel secure as a person (Left/Yin), or express healthy levels of pride in oneself and/or one's life (Right/Yang).

Imbalanced Energy: one may fear to be oneself or live passionately (Left/Yin), or lack pride in oneself and/or life (Right/Yang).

Lower Legs

Location: The Lower Legs include the shins and calves.

Balanced Energy: one may express grief in a healthy way (shins) or feel strength to move forward with one's life after changes (calves).

Imbalanced Energy: one may feel an impasse to move forward, get "tripped up" on one's thoughts or ideas, or struggle to find ways to move on.

Feet

Location: The Feet include the ankles, toes, Achilles' tendon, heels, both right and left.

Balanced Energy: one may be flexible with what comes, be firmly grounded to one's past (Left/ Yin) or one's future (Right/ Yang).

Imbalanced Energy: one may feel disconnected from one's origins, or one's family and ancestry (Left/ Yin), from Mother Earth or one's root energy, or from one's immediate future (Right/ Yang).

Symbology

There are six symbols that I regularly work with: spirals, dots, lines, moon phases, crosses, and arrows. These symbols are defined in my personal symbol library and add an extra layer of information to my readings. You can choose to use whatever symbols you'd like in your artwork, or you can choose to not use any. If you decide to work with them, here are the interpretations of the symbols I use.

Spirals

Generally, spirals show me which way a chakra is spinning, either by moving clockwise or counter-clockwise. If a chakra is spinning clockwise, it tells me a person is working on building, creating, doing, and giving. In other words, they are focused on what's happening in the physical realm.

Counter-clockwise spirals tell me that a person has retreated inward. They focus on learning, receiving, trusting, building faith, and otherwise surrendering to the moment and circumstance. They are focused on what's happening inwardly to the Self.

For example, let's say I add a spiral spinning counter-clockwise in the heart chakra. This symbol tells me that the person has turned inward and may be practicing how to receive love, whether in their partnerships, through their community, or healthy self-care rituals.

If the spiral were spinning clockwise in the heart chakra, this would tell me the person may be a focused caretaker to others or may be exerting a lot of energy in their relationships.

Here are a few interpretations of spirals in the chakras to get you started:

Crown Chakra

Counter-clockwise spiral: Seeking answers through spiritual practice, a cosmology, or practice of faith.
Clockwise spiral: A strong spiritual connection to cosmology or personal practice. Seeing how one can fit into the "bigger picture." Someone who regularly attends church, practices meditation or yoga, or is currently working on manifestations, affirmations, or mindfulness practices.

Third-Eye Chakra

Counter-clockwise spiral: May experience a blocked perspective on a situation or challenge, unable to "see" one's way through a problem or circumstance, a loss of dreaming either metaphorically or literally.
Clockwise spiral: Third-eye chakra is open. It shows a clear perception of life and denotes staying open to new ideas and opportunities.

Throat Chakra

Counter-clockwise spiral: May experience trouble articulating what to say. Inability to express one's real needs. Seeking the right vocation to express oneself through work or career meaningfully. Someone who is taking careful consideration of their words and how they use them.

Clockwise spiral: Throat chakra is open. Honest expression. Feels safe to express oneself. Communicating fully with others. Feels satisfied with current work or career.

Heart Chakra

Counter-clockwise spiral: Learning how to connect with others, their community, or the lives that they have built. Searching for a greater sense of belonging, seeking out love and self-love.

Clockwise spiral: Feeling connected to the life they've built and the people around them. Feeling loved. Feeling "whole." Easily relates to others and connects meaningfully to their loved ones and community.

Solar Plexus Chakra

Counter-clockwise spiral: Learning how to connect to the lives we have built. May be experiencing challenges in feeling connected to who they are as a person. Can be a sign of an "ego-death", where a person is transitioning from one significant life stage into another.

Clockwise spiral: Feeling strong and self-assured. Expressing self-confidence and understanding. Knows ones limitations and practicing healthy boundaries.

Sacral Chakra

Counter-clockwise spiral: May feel disconnected sexually. Lacking creativity or ability to efficiently problem solve. Repressed emotions. Someone who is focused on healing emotional memories and repressed memories.

Clockwise spiral: Shows someone who is honoring their emotions and honoring creativity—a fertile time in one's life. Abundant creativity. They may be experiencing many different emotions all at once.

Root Chakra

Counter-clockwise spiral: Feeling like they're not in the right spot. A recent challenge that's "shaken" them up. Disconnection from the true self or family.

Clockwise spiral: Feeling connected to family or heritage. Able to see oneself truthfully. Feeling strong and empowered. Focused on building and creating things in their life.

Dots and Lines

Use dots and lines at random and interchangeably. When I add dots and lines to a chart, I don't think about the number or the sequence. I add them and let it be. Later, I count the symbols in their respective space and apply the meaning.

For example, let's say I feel called to embellish a leg. I add a series of dots to the chart without thinking about it. Once the chart is complete, and I'm reading the root chakra where the dots were drawn, I'll count the number used to embellish the artwork. My number interpretations are as follows:

- One = New beginnings, a new cycle
- Two = A new choice or decision must be made, or a new direction moved into
- Three = A call to action, making a commitment to a plan or choice and sticking to it
- Four = Rest, respite, and relief; a break
- Five = Sudden and unexpected change, a new direction
- Six = A time for communication, caregiving, nourishing, and rebalancing
- Seven = A sudden shake-up or need to step outside of the comfort zone
- Eight = Continued hard work, dedication, and focus are needed now
- Nine = Completion is near; final obstacles are being cleared now

Moon phases

Each moon phase reveals essential information about a person's current stage of life. Moon phases show up in the same way all my symbolism does—authentically and randomly. Simply put, if I feel moved to draw a moon, I do. When I am reading through that specific chakra, I apply the knowledge about that particular moon phase to the reading.

Here is how I interpret moon phases:

New Moon: A perfect space for retreating, establishing new self-care rituals, and nourishing oneself. This is a rich space for deep dreaming and setting new intentions.

Waxing Crescent: This is a beautiful time for putting thought into action and continue to nourish the seeds sown during the new moon.

First Quarter: This is a time when challenges or obstacles appear in the way of us manifesting our intentions. We begin to build resistance to our plans and ideas. Don't give in—keep going!

Waxing Gibbous: This is a perfect time to make adjustments, edits, changes, or otherwise reevaluate our course or direction.

Full Moon: Emotions and energy may be high, which gives an extra edge to completing goals. More care and attention to rebalancing ourselves is important now.

Waning Gibbous: This is a wonderful time to share our intentions with others and express our gratitude to the universe for its help in conspiring on our behalf for success.

Last Quarter: To make room for the new intentions to expand and grow, we need to clear space. This is a great time to release judgments against oneself and others, to forgive and let go.

Waning Crescent: We've done what we can throughout the journey. We've sown the seeds and put in our calls to action. We've made adjustments and problem-solved. We've shared our intentions with others and expressed gratitude. We've cleared space so our good work can grow. Now, it's time to release our expectations and surrender our will to the Universe. Rest, release, and trust in the process.

Crosses

Crosses generally appear in the crown and throat area, the chakras of trust and purpose. In my work, crosses denote where a person either has recently been or is challenged with having faith in themselves, in others, or a higher plan.

Arrows

Like spirals, arrows mark the directional flow of energy. They act as connectors on the map, bridging two separate concepts together to show how the body's stories are connected. For example, if there is a marking in the sacral chakra and another in the heart, an arrow may join them, showing me that each chakra's two interruptions are related.

Let's use the color dictionary and the body interpretations to read the subtle body's information in the following examples.

Example Reading One

A deep-red, maroon color appears in the crown chakra.

Begin reading the body by looking at the color. Turn to Page 66 to interpret deep red or maroon. Maroon is defined as a color that appears when one feels aggression, anger, fear, or an inability to see past emotions.

Next, look at the location of the color. In this case, maroon is in the crown chakra (See Page 73). The crown chakra is a placeholder for acceptance, trust, and surrender to all we cannot control.

The third and final step is to put the two pieces of information together to form one cohesive thought. This person may be feeling angry or fearful (maroon color). Those emotions are so strong that it's preventing this person from accepting or trusting the greater plan of what's going on in life (Crown Chakra).

What are your immediate impressions of the color?

What are you first impressions of the location?

How do you interpret the two together?

Let's try another example.

Example Reading Two

A brilliant blue color appears in the throat chakra on the chart's left side, the yin side.

First, read the color. Turn to Page 68 to learn that blue is a color that shows up during healthy communication periods. When we practice clear communication with ourselves and others, we listen to our intuition or seek clarity and truth.

Second, read the location. The yin side of the template, the left-hand side of the body, represents the psyche and the inner self, so I know that these are internal feelings.

The throat chakra is responsible for helping us speak kindly and compassionately. A balanced throat chakra knows precisely what to say and when to say it. It articulates our truth, helps us be who we are, and find our life's purpose. (See Page 72).

The final step is to put the two pieces of information together to form one cohesive thought. A brilliant blue shares that there is a strong self-communion period (color). This person is learning how to speak kindly and compassionately to the Self (Left-side of the throat chakra).

What are your immediate impressions of the color?

What are you first impressions of the location?

How do you interpret the two together?

Let's try another example.

Example Reading Three

A muddy, murky green color appears in the heart chakra on the yang (right) side near the lungs.

First, read the color. Turn to Page 68 to learn that a muddy green color shows up during periods of deep grief, sadness, or jealousy indicating that the energy may be blocked.

Second, read the location. The yang (right) side of the chart represents the energy of the doer, analyzer, and builder. Turn to Page 87 to learn that the lungs are where we become open to new ideas and practice good communication. When energy is blocked, the lungs store our grief and sadness.

Now, put the two pieces of information together. Muddy, murky green shares that this person may be in a period of deep grief or sadness (color and the lungs) that may be caused by an experience in this person's life happening in the present day. (Yang /right side of the chart.)

What are your immediate impressions of the color?

What are you first impressions of the location?

How do you interpret the two together?

Let's try another example.

Example Reading Four

Both legs are painted brown except for a little bit of bright red peeking through the template's right ankle, the yang side. First, read the color. Turn to the color dictionary on Page 67. Brown is interpreted as a friendly, warm, earthy color. It's the color of a person who loves the outdoors. It shows up when someone is a grounded, comfortable, and dependable soul. Bright red is a color that's passionate, warm, and lively.

Next, read the location. For this person, break up the location into two areas, the legs and left ankle. We know the chart's yin side represents the mind's inner workings, psyche, and deepest self. (Page 82). The legs in a Chakragraph chart represent the root chakra. (Page 93) The root chakra cultivates independence, stability, security, and celebrates accomplishments. The left ankle represents flexibility, and how firmly grounded we feel to our past. (Page 91)

Now, put the information together. Warm, earthy brown shares that this person's inner and outer Self is very stable, comfortable, and secure (color and root chakra), but they may have some passionate feelings tied to their past that could be coming up for processing. (Yin/left ankle)

What are your immediate impressions of the color?

What are you first impressions of the location?

How do you interpret the two together?

CHAPTER TEN

HOW TO READ YOUR CHAKRAGRAPH

Reading these charts may feel like second nature, but if it feels difficult, stick with it. With practice, you'll make the connections and see the colors and symbols align with your natural talents. Everyone intuits different information and in different ways. It may take time to understand the most comfortable and natural methods for you. If you follow the system and use the information given to you, you'll come up with the right answers every time.

Step 1. Create Sacred Space

Create sacred space in whatever way feels right to you. For examples on how to create sacred space, turn to Page 27.

Step 2. Set Your Intentions

Once you open sacred space, sit quietly with your hands on a blank watercolor page and say your intention out loud. So, if you are painting yourself, say, *Today, I am painting myself. Please connect me to my subtle bodies. Spirit, move me out of the way, so I can render myself through your eyes and speak of myself compassionately through your words.*

Step 3. Transfer The Template

Transfer the template to your watercolor paper using the graphite paper and a printed template. For step-by-step directions on this process, turn to Page 49. Remember, if a piece of the template is missing, it's okay and becomes part of the reading. Look on Page 52 for interpretive meanings about what a portion of a missing template may mean. Make note of any inconsistencies or impressions before you paint your template. If you have limbs or portions of limbs missing, do you feel moved to fill them with color or leave them blank? There are no wrong answers.

Step 4. Time To Paint!

Remember, when you are painting a Chakragraph, you are a channel for the Divine to come through. Be aware that this is not the same as receiving impressions while you paint. You'll know the difference between the two because one requires analysis, and the other will be a quick, quiet burst of inspiration

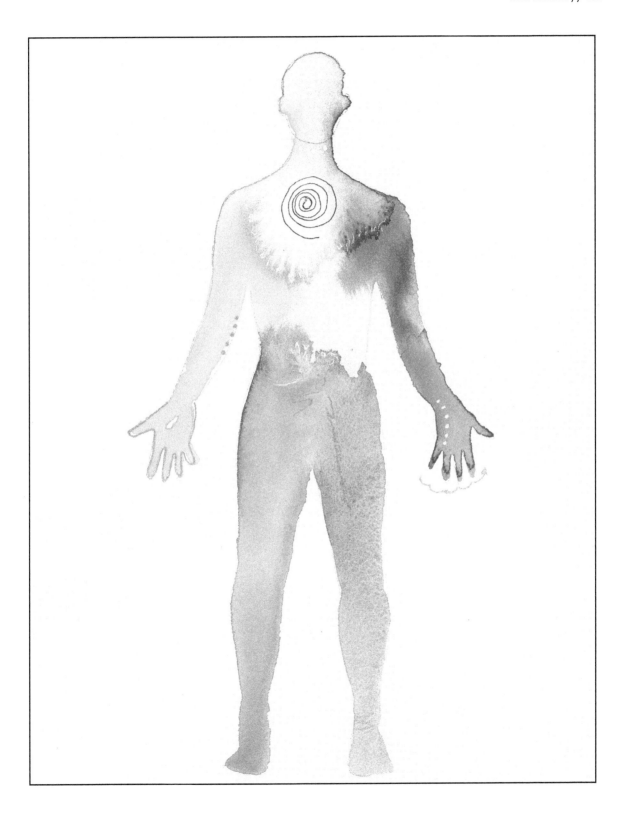

or information that leaves as quickly as it comes. Keep a notepad and pen nearby to record impressions. Then, immediately return to the painting.

Allow your brush to guide you to the colors. You may "hear" a very soft voice inside whisper a color to use, or you may "see" a color flash in your mind's eye. Your painting space may be quiet to allow the colors to grace the paper how you are led. Clean the brush in between each color, or allow one color to blend into the next. Follow your intuition on choosing and mixing colors. Then, give the completed artwork a little time to dry. There is no set amount of time to complete a Chakragraph.

Step 5. Add Embellishments Or Symbology
Embellishments can be purely decorative or functional symbology that add depth to the reading. For a list of the symbols and their meaning, turn to Page 92. Feel free to create and define the symbols that come to you.

Step 6. Scan the Chakragraph with Soft Eyes
Do any animals, plants, stones, other Beings, or symbols appear? What messages or medicine might they bring with their appearance?

Look at the Chakragraph as a whole. Does one area of the Chakragraph catch your eye over another? If so, how do you interpret that specific message's importance?

Lastly, consider the overall tone of the Chakragraph. Is it bold? Subdued? Confident? Chaotic? What might that say about the person you're reading for?

Step 7. Interpret the Template
Are there any parts of the template missing or disconnected? Are there any irregularities in the template size? If so, consider what that might mean. Turn to Page 52 for some interpretations, or create your own. Add to any notes you took when tracing the template.

Step 8. Interpret the Colors and Locations
Start at the crown. Begin to identify the colors that show up on your Chakragraph. Use the supporting color dictionary on Page 66 to help identify colors and their meanings and the location chart on Page 82.

Chakragraph Worksheet

I've created a simple worksheet to help you move through the Chakragraph process with ease. You can complete an entire reading from start-to-finish using this worksheet. Download the worksheet at **www.jamiehomeister.com/chakragraph-support/worksheets**

1. Examine the template. Are there any parts of the body template missing? If so, what and where? You can refer to Page 52 in the book for some interpretive suggestions.
2. Now redirect your focus on your entire completed Chakragraph. Scan over it with soft eyes. Are there any objects, symbols, or animals hidden in the paint that stand out to you? What, if any, are your immediate impressions about what you see?
3. Next, do a quick scan of your colors. Try to answer the following:
 • What is the most predominant color in the chart? And what might this say about the person you're reading for?
 • Are there any places where color is missing? If so, where? What do you think that means?
 • Are there any colors that appear darker or lighter than the rest? What does that mean to you?
 • What is the overall feeling of the colors in the chart?

Moving Through the Chakras

1. Crown Chakra: Acceptance, Faith, Trust & Surrender

Note what colors are present in the crown chakra.
Left Side (Internal/Psyche):
Right Side (External/Mental):

What impressions, feelings, or beliefs do these colors bring to mind? Try to record the first three impressions that you receive. Refer to Page 66 for insights from the color dictionary, Page 70 for chakra information, and Page 82 for the body dictionary.

Are there any symbols or animals appearing in the chakra? If so, what do you think they add to the information you have already recorded?

2. Third-Eye Chakra: Perspective & Intuition

Note what colors are present in the third-eye chakra.
Left side (Internal/Psyche):
Right side (External/Mental):

What impressions, feelings, or beliefs do these colors bring to mind? Try to record the first three impressions that you receive. Refer to Page 66 for insights from the color dictionary, P 70 for chakra information, and Page 82 for the body dictionary.

Are there any symbols or animals appearing in the chakra? If so, what do you think they add to the information you have already recorded? Turn to Page 92 for help with a symbol library.

3. Throat Chakra: Communication & Vocation

Note what colors are present in the throat chakra.
Left Side (Internal/Psyche):
Right Side (Physical/Mental):

What impressions, feelings, or beliefs do these colors bring to mind? Try to record the first three impressions that you receive. Refer to Page 66 for insights from the color dictionary, Page 70 for chakra information, and Page 82 for the body dictionary.

Are there any symbols or animals appearing in the chakra? If so, what do you think they add to the information you have already recorded? Turn to Page 92 for help with a symbol library.

4. Heart Chakra: Love and Relationships

Note what colors are present in the heart chakra.
Left side (Internal/Psyche):
Right side (Physical/Mental):

What impressions, feelings, or beliefs do these colors bring to mind? Try to record the first three impressions that you receive. Refer to Page 66 for insights from the color dictionary, Page 70 for chakra information, and Page 82 for the body dictionary.

Are there any symbols or animals appearing in the chakra? If so, what do you think they add to the information you have already recorded? Turn to Page 92 for help with a symbol library.

5. *Solar Plexus Chakra: Identity & Personal Power*

Note what colors are present in the solar plexus chakra.

Left Side (Internal/Psyche):

Right Side (Physical/Mental):

What impressions, feelings, or beliefs do these colors bring to mind? Try to record the first three impressions that you receive. Refer to Page 66 for insights from the color dictionary, Page 70 for chakra information, and Page 82 for the body dictionary.

Are there any symbols or animals appearing in the chakra? If so, what do you think they add to the information you have already recorded? Turn to Page 92 for help with a symbol library.

6. *Sacral Chakra: Emotions, Creativity, & Passion*

Note what colors are present in the sacral chakra.

Left Side (Internal/Psyche):

Right Side (Physical/Mental):

What impressions, feelings, or beliefs do these colors bring to mind? Try to record the first three impressions that you receive. Refer to Page 66 for insights from the color dictionary, Page 70 for chakra information, and Page 82 for the body dictionary.

Are there any symbols or animals appearing in the chakra? If so, what do you think they add to the information you have already recorded? Turn to Page 92 for help with a symbol library.

7. Root Chakra: Safety, Structure, Security, Stability

Note what colors are present in the root chakra.
Left Side (Internal/Psyche):
Right Side (External/Physical):

What impressions, feelings, or beliefs do these colors bring to mind? Try to record the first three impressions that you receive. Refer to Page 66 for insights from the color dictionary, Page 70 for chakra information, and Page 82 for the body dictionary.

Are there any symbols or animals appearing in the chakra? If so, what do you think they add to the information you have already recorded? Turn to Page 92 for help with a symbol library.

If you gain any insights or impressions along the way, include them in your summary to either reflect on or share with others as you review your work. It is an important part of the process to put the artwork on display. Its meaning will continue to blossom in your unconscious mind. You may just surprise yourself with what comes up weeks later!

I hope this practice fills you with as much insight, joy, and pride as it's given me and so many others throughout the years. I hope you have fun and share it with other people. May you all be joyful in your execution, compassionate in your delivery, and find fun every step along the way.

With tremendous gratitude,

Jamie

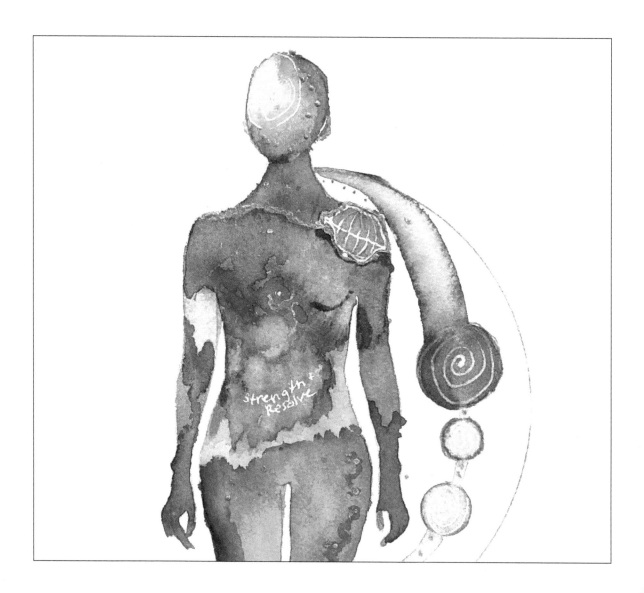

Female Form Template

CHAKRAGRAPH

COLOR DIVINATION

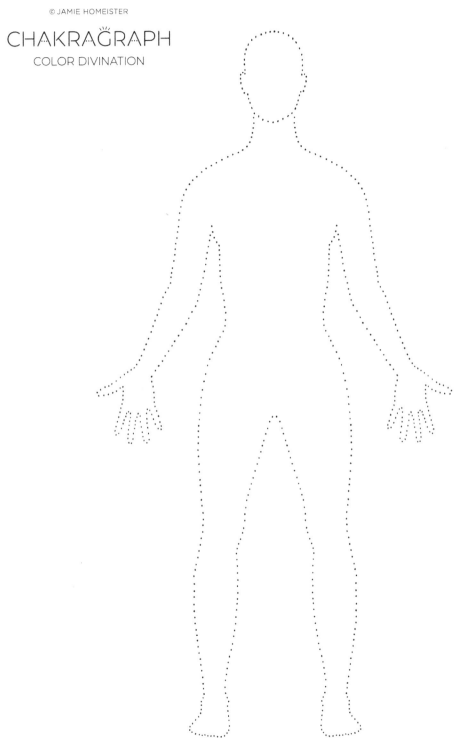

Male Form Template

CHAKRAGRAPH
COLOR DIVINATION

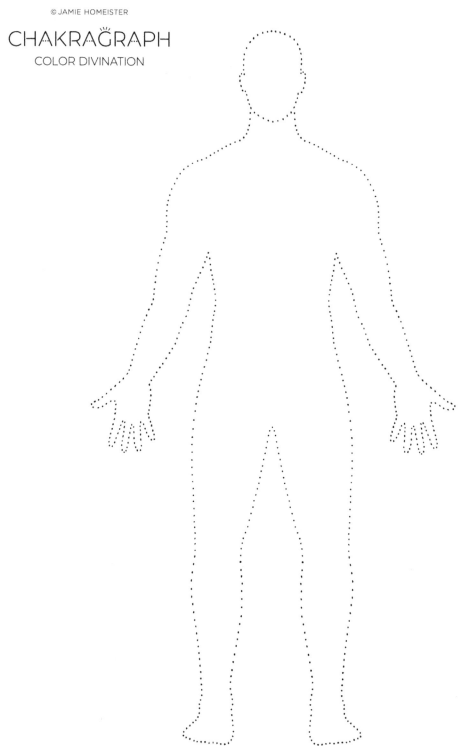

Gender Neutral Form Template

CHAKRAGRAPH
COLOR DIVINATION

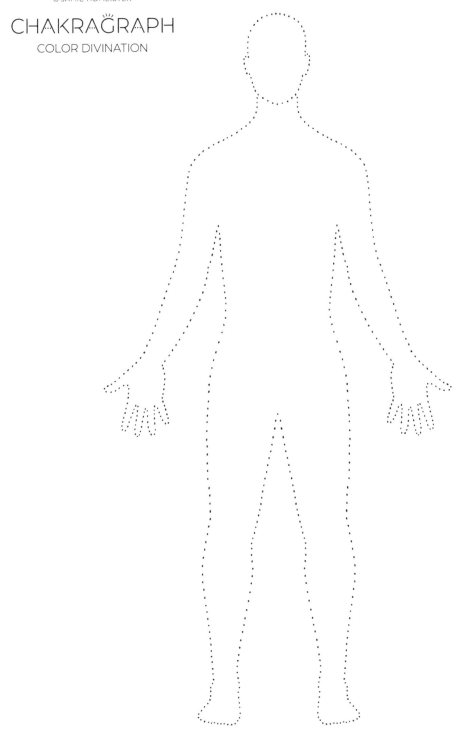

GLOSSARY

Aura: A colored emanation or electromagnetic field said to enclose the human body, animal, or object.

Bead: A tiny pool of water formed at the bottom of a watercolor brushstroke.

Belly: The middle of a round brush.

Blind readings: Readings where there are no "tells" given; no vocal cues or body language for a reader.

Bleed: Where two or more colors naturally come together in watercolor.

Buckling: When paper warps and indents from being overly saturated with liquid.

Chakra: (From Indian philosophy) each of the centers of spiritual power in the human body.

Chakragraph: An illustrative, artistic interpretation of the chakra system and subtle bodies.

Channeling: To serve as a medium; entering a meditative state in order to convey messages from Spiritual Guides.

Chi: Universal life-force energy, also known as prana, breath of life.

Clairalience: The ability to smell scents and odors without explained sources.

Clairaudience: The ability to hear sounds and voices beyond the normal senses.

Clairempathy: The ability to feel other people's, animal's, or plant's emotions or energy as if it were your own.

Claircognizance: The ability to gain psychic information without knowing how or why they do it.

Clairvoyance: The ability to perceive things or events beyond the normal senses.

Cold-press paper: Watercolor paper with a midrange amount of grain, "tooth," or texture.

Diffuse/drops: The process of dropping wet paint onto wet paper and letting it dry naturally.

Divination: The practice of seeking knowledge of the future or the unknown by supernatural means

Ferrule: A metal sleeve that binds the handle to the bristles of a brush.

Hot-press paper: Watercolor paper with no grain, "tooth," or texture.

Hue: A color or a shade of a color.

Intention: What one intends to do or bring about.

Intuitive: A person who emotes and feels strongly, even without conscious reasoning; instinctive; psychic; empathic.

Intuitive hits: Intuitive insight and information.

Line of Light: The threshold of one's integrity; What we are, and what we're not willing to do.

Mixing tray: A palette with little cups built into it, which the artist uses to mix watercolor colors.

Medium: A person who communicates with the *other side* using extrasensory gifts and talents.

Muddy: Colors that appear murky, hazy, or discolored from their original hue.

The Other Side: Refers to the other side of the veil; the spirit world; point past death.

Palette: The range of colors in which an artist uses for a particular picture; a thin plastic, glass, or wooden slab on which an artist lays or mixes their paint colors on.

Pigment: A colored material that is completely or nearly insoluble in water.

Priming the page: Preparing your watercolor paper by coating it with an even layer of clean water.

Prana: See *chi*.

Psychic: A person with extrasensory perception who obtains information not using the ordinary senses.

Querent: A person who questions an oracle, medium, or psychic.

Rough watercolor paper: Watercolor paper that has a prominent tooth or textured surface.

Sacred space: Any place, area, or person dedicated to a Holy purpose.

Saturation: The intensity of a color.

Seer: A person with extrasensory talents who communicates with the 'Other Side,' spirits, or angelic realm.

Sitter: The client or participant receiving the reading.

Spirit: The nonphysical part of a person which is the seat of emotions and character; the soul.

Spirit: Higher Power, God, Source Energy, the Divine, the Soul.

Soul: See *spirit*.

Subtle body: Considered to be various energetic layers that make up a human being beyond physicality.

Tint: A shade or variety of a color.

Tooth: The texture of watercolor paper.

RESOURCES

Watercolor Teachers

handprint.com / Bruce MacEvoy, Watercolorist and Educator

susanchiang.com / Susan Chiang, Watercolorist and Educator

thepostmansknock.com / Lindsey Bugbee, Calligraphy Blogger and Watercolorist

watercoloraffair.com / Anthony Roebuck, Watercolorist and Educator

Books

Does Your Body Lie?, Louis Martins Simones, Independently Published, 2020

Heal Your Body, Louise Hay, Hay House Inc., 1984

Llewellyn's Complete Book of Chakras: Your Definitive Source of Energy Center Knowledge for Health, Happiness, And Spiritual Evolution, Llewellyn, 2006

The Subtle Body: An Encyclopedia of Your Energetic Anatomy, Sounds True, 2009

Walking in the Light: The Everyday Empowerment of a Shamanic Life, Sandra Ingerman, 2015

You Can Heal Your Life, Louise Hay, Hay House Inc., 1984

Watercolor References (see pigment color list Page 32)

www.artistsnetwork.com/art-mediums/watercolor/watercolor-painting-what-you-need-to-know-about-watercolor-pigments/

www.explainthatstuff.com/howpaintworks.html

www.webexhibits.org/pigments/intro/watercolor.htmlbexhibits.org/pigments/intro/watercolor.html

www.watercolorpainting.com/pigments/

www.watercoloraffair.com/complete-guide-to-watercolor-wash-techniques (Watercolor Wash Techniques, Page 42)

www.handprint.com/HP/WCL/wet1.html (Working With Water Ratios, Page 41)

www.corepotentials.ca/blog/clair-empathy (clairempathy, Page 22)

crystalearthspirit.com/pages/exercises-for-seeing-and-sensing-auras (Exercise for Sensing Your Aura, Page 61)

www.healthline.com/health/what-is-an-aura (Auras, Page 56)

www.mindbodygreen.com/0-25407/what-is-an-aura-and-how-can-you-see-yours.html (Auric Body or Planes, Kathryn Grace, Page 56)

www.insider.com/what-is-an-aura-2019-4 (Auras, Edgar Cayce, Page 56)

mindisthemaster.com/subtle-bodies/ (Subtle Bodies, Page 57)

www.yogapedia.com/definition/9818/subtle-body (Subtle Bodies, Page 57)

Chakragraph Downloads

Support posts, downloadable materials, videos, and tutorials are available on my website at:
www.jamiehomeister.com/chakragraph-support

Special Mentions

Barbara Bloecher, Shamanic Teacher and Practitioner | www.shamansearth.com

Christina Pratt, Podcast Host, Shamanic Teacher and Practitioner | www.lastmaskcenter.org

Gina Millard, Shamanic Teacher and Practitioner | www.shamansfire.live

Megan Mraz, Graphic Designer and Chakragraph Template Creator | www.hellomeggo.com

MaryBeth Bryant, Photographer for *Introduction to Chakragraphs* | www.candidmb.com

ACKNOWLEDGMENTS

I'd like to thank my husband, TJ Homeister, for believing in me when no one else would, not even me. You helped this platform become what it is today. I couldn't be more grateful for you in my life.

I want to thank my mentors, Barbara Bloecher and Gina Millard, both of whom wrapped me up in their love and grace to lead me when I was floundering. In truth, I was learning.

To my children, who teach me so much about love and life every single day. I'd never want to imagine a life without you.

To my helpers in Spirit, thank you, thank you, thank you! You led me from the ashes and into the dawn and allowed me to reimagine my life in a way that's rich with value, meaning, and connection.

Thank you to my editor and Book Witch, Heather Dakota, who supported me through this project's immense conception. To MaryBeth Bryant for supplying the photographs for this book, and Megan Mraz for her clever design skills to create these original illustrations and recreate the Chakragraph templates.

And lastly, to all the beautiful souls who put their trust in me over the years and built my practice to what it is now: Thank you. I appreciate you more than my words can ever say.

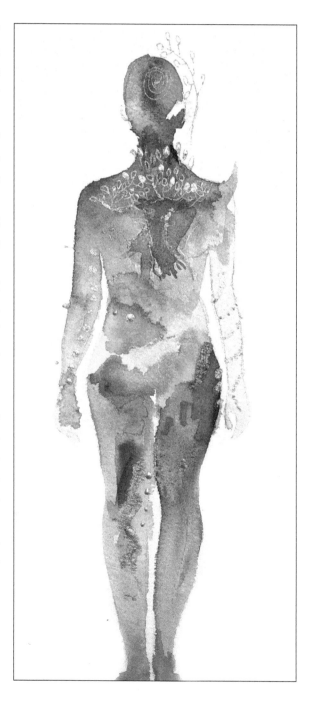

ABOUT THE AUTHOR

Jamie Homeister is a psychic, intuitive artist, and The Chakragraph System founder. When Jamie turned thirty years old, she learned that she was an empath, an intuitive, and a spirit medium. Jamie quickly learned how to combine her unique life experiences, talents, and sensitivities to support others through their own lives and challenges.

Currently, Jamie resides in Southern Indiana with her husband, three children, and Golden Retriever named Arlis. She operates her spiritual practice and still offers Chakragraph readings and workshops today.

Jamie is available for podcasts, interviews, and book events. Please send an email to jamie@jamiehomeister.com with inquiries.

LEARN MORE ABOUT READINGS & CLASSES

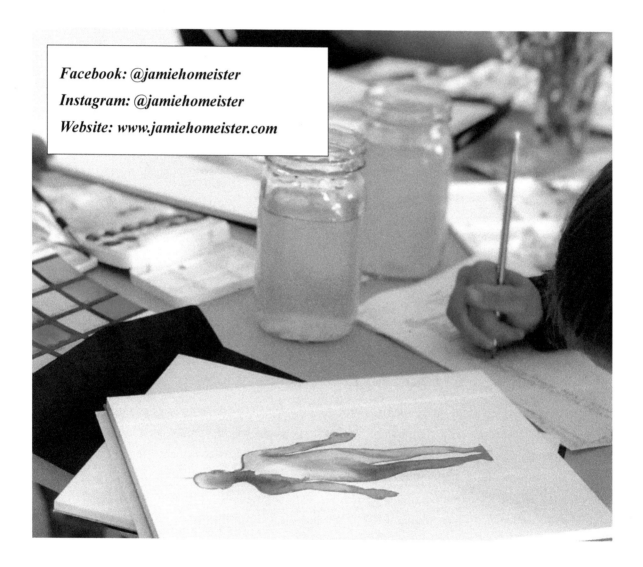

Facebook: @jamiehomeister
Instagram: @jamiehomeister
Website: www.jamiehomeister.com

If you would like to amplify the beauty of Chakragraphs, please leave a review on Amazon and GoodReads.

Thank you!
–Jamie

CPSIA information can be obtained
at www.ICGtesting.com
Printed in the USA
LVHW071308040921
696964LV00003B/11

9 781735 072692